Who Makes
the Fash

What Cultural Strategies are Shaping the
Re-emergence of Fascism?

Who Makes the Fash

What Cultural Strategies are Shaping the Re-emergence of Fascism?

Luca Carboni

Winchester, UK
Washington, USA

JOHN HUNT PUBLISHING

First published by Zero Books, 2020
Zero Books is an imprint of John Hunt Publishing Ltd., No. 3 East St., Alresford,
Hampshire SO24 9EE, UK
office@jhpbooks.com
www.johnhuntpublishing.com
www.zero-books.net

For distributor details and how to order please visit the 'Ordering' section on our website.

ISBN: 978 1 78904 319 8
978 1 78904 320 4 (ebook)
Library of Congress Control Number: 2019934079

A CIP catalogue record for this book is available from the British Library.

Design: Stuart Davies

UK: Printed and bound by CPI Group (UK) Ltd, Croydon, CR0 4YY
US: Printed and bound by Thomson-Shore, 7300 West Joy Road, Dexter, MI 48130

We operate a distinctive and ethical publishing philosophy in
all areas of our business, from our global network of authors to
production and worldwide distribution.

Contents

This work would not have been possible without the sharp guidance and encouragement of Marina Vishmidt and the brilliant editing of Andrea Garcés. To them goes my utmost gratitude and admiration.

This book is dedicated to the 34,631 migrants who have died while attempting to cross the Mediterranean Sea since 1993[1], to the countless others whose deaths and sufferings are not known and recognized, and to those whose daily lives are oppressed by some of the most rich and unapologetically racist and patriarchal nations in the world. With the promise that those who rally the masses and enforce this barbarity will pay the dear price that History sets for those like them.

C'è sempre posto a Piazzale Loreto.

Who Makes the Fash? is a compelling analysis of the relationships between art and fascism. Originating from the desire to conceptualize an antifascist artistic practice, this book investigates fascism in Italy and its relationships with futurism and neoliberalism. When seen in a historical context, the aesthetic appeal of the "new", glamorous fascism is unmasked as a media-sponsored strategy of smoke and mirrors, functional to the preservation of a racist and patriarchal capitalism disguised as anti-systemic and innovative (from CasaPound to the 5 Star Movement in Italy, to Elon Musk – hopefully soon in space). What role can the arts have in this scenario? The assumption that this field is a stronghold of the left cannot be held true anymore: if as artists we want to counter the making of fascist hegemony, we must embrace a responsibility that goes beyond our practice. This book offers an accessible historical overview, political analysis and a passionate call to radicalize the politics and practices of arts and culture around an outspokenly antifascist praxis.

Introduction

Is Fascism Making a Comeback?

On the morning of 17 July 2018, the crew members of the NGO rescue vessel Open Arms spotted, floating 80 miles off the Libyan shores, the debris of what would later turn out to be a rubber dingy, like those used by migrants to cross the Mediterranean Sea. As soon as the rescue team approached the floating objects, they realized that three bodies were being kept afloat by the wooden plates. The bodies were those of two women and a child of approximately 4 years of age. Only one of the women was alive, in a state of hypothermia. The child appeared to have died only a few hours before.[2]

Josefa, the only survivor, said later that she had been in that situation for 2 days, after a vessel of the Libyan Coast Guard intercepted the boat and announced that the migrants were going to be brought back to Libya, according to the bilateral deals signed with the previous Italian Government. The two women, who probably refused to comply with the orders, were beaten, their boat destroyed and left afloat on the debris in the middle of the sea. The Nigerian woman told the rescuers that she had escaped her house because of domestic violence. After being denied the right to land in Italian ports by the Italian Interior Minister Matteo Salvini (who announced, on Twitter, a highly controversial and illegal "closed ports" policy, which had the effect of disrupting the search and rescue operations in the western Mediterranean), the Open Arms vessel reached the coast of Spain, after an additional week of navigation in high seas.

As terrifying as Josefa's story sounds, being left to die on a piece of trash in the middle of the sea might not be the worst aspect of the affair. What is most chilling, in fact, is how this episode has been received in Italy. A few days after the news

hit the media, thousands of Facebook users, perfectly average people, according to their profiles, started to question the authenticity of the episode, claiming that the photos of the rescue were fake, because of the most disparate allegedly "unrealistic" details, along with bad jokes, body shaming and the sharing of cartoons ridiculing the woman. The strongest "evidence" was a photo taken a few days after the rescue, in which Josefa lies on a stretcher wearing red nail polish. This detail alone, hundreds, thousands claimed, tells the fakeness of the story: who would care about nail polish when escaping war, misery, hunger?[3] The journalist Annalisa Camilli, on board of the vessel, clarified that the nail polish was applied in the following days by the women on board in an attempt to ease her shock and get her to start disclosing the details of the shipwreck.[4] Days later, it emerged that the first to spread this fake news was a right-wing Twitter influencer who periodically receives money from the media outlet of one of Italy's main neo-fascist organizations.[5]

This kind of collective "forensic" analysis, carried out on social media by self-appointed popular courts ("I've been on a boat once, that shadow doesn't look right to me!! Who would wear nail polish when escaping war? Wake up!! This photo is fake!!!!"), used to be the domain of conspiracy theory blogs and holocaust deniers' circles. Nowadays, the denial of even the humanity of shipwreck survivors seems to be something totally acceptable and in line with the common sense that appears to have surged to the role of ruling hegemony. Sadly, episodes like this are becoming more and more frequent. Intolerance has grown towards all forms of migration, alongside an impoverishment of the general political discourse, whereby compassion can be defined as a flaw to get rid of, and the weakest in society are becoming the targets of widespread hostility – when not of openly violent and deadly attacks[6] –from both authorities and more privileged subjects. Meanwhile, the media system enthusiastically portrays marginal, neo-fascist initiatives as original, widespread and

legitimate within the normal, democratic unfolding of the political discourse. In the field of institutional politics, there has been a steady contraction of labour rights, the adoption of openly racist policies regarding citizenship and migration, rising bigotry around issues regarding women's rights, harsh austerity measures that have led to a fierce privatization of state services and institutions while punishing the working class, and escalating tension between nations and their spheres of influence in a climate of rising nationalism. Are these symptoms of a new wave of fascism within Western[7] societies?

Surely, there seems to be a diffuse feeling something has changed: every day the bar gets lower and a new common sense, marked by the dehumanization of the other and the mouldering of previously consolidated rules, seems to gain more traction, in a vicious circle in which political leaders follow and embolden the angry belly of the common people. The increasing resort to offbeat modalities of governance – like bold appeals to a mass of followers on social media, calling for exceptional measures oftentimes outside the law, instead of normal legal and parliamentary procedures – also recalls the propaganda as a mode of governance typical of twentieth-century dictatorships. A new kind of power seems to be interested in stirring a pot of irrational, negative and often volatile feelings, which are difficult to govern, instead of creating the conditions for stability.

The aspect of the disqualification of the institutional politics and its role in the legitimization of previously unacceptable discourses and modalities hits equally on the right and on the left. Indeed, it is perhaps on the left that such a tendency becomes more problematic: the left-wing parties – or what is left of them, after the generalized absorption of neoliberal ideology post-1989 – are embracing policies and a rhetoric that used to be typical of post-fascist formations.[8] When the left wing is politically unable to turn this rhetoric into policy, it paves the way to power for the extreme right, which, because

of its constitutive character, is able to successfully implement the policies that otherwise would meet opposition from civil society. Therefore, it is not surprising that extreme-right parties, once relegated to the political margins, are now finding electoral success throughout Western Europe following their rebranding as centre-right, populist parties with simple but reasonable policies for, allegedly, the protection of the national working class. The rise of the hard right in Hungary, Poland, Ukraine and throughout Eastern Europe is now being mirrored in similar right-wing surges in France, Germany, Austria, The Netherlands and Greece. The last Italian election consecrated Matteo Salvini as the new leader of an extreme right which, in his own words, "is going to govern Italy for the next 30 years".[9] In the country that gave Mussolini to the world, in which the left-wing opposition has laid in a state of coma for the last 2 decades, and the largest political force is a "movement" composed of amateur "folk politicians" chosen with online primary elections, with close-to-zero institutional experience, and inspired by a TV comedian, these words sound quite unsettling, albeit quite pretentious. Looking further afield in the English-speaking world we find Brexit and Trump, whose ambiguous relationship with Putin's Russia seems to bring back a deformed cold-war scenario. Warnings of an imminent return of fascism echo more and more frequently in the mainstream press as well as in professional political and artistic circles.

A superficial glance at this constellation might result in thinking that everybody is going nuts, and all reference points we used to base our judgements upon are subverted. Seen with other eyes, however, the chilling picture is one of a trial run for a new round of outright fascism. The most recent, controversial moves by these new emboldened leaders (for example the Trump administration's policy of separating migrant children from their families, and locking them in cages, or the barbarian management of migration flows in the Mediterranean by Salvini)

resemble the practices of Nazi concentration camps, and even if on a smaller scale and sometimes short lived, they get each time more brutal, and seem to be a way to test public opinion and slowly accustom the minds to the fact that some ethnicities and categories of people can be made subject to such inhuman treatment among general indifference.[10] If we lulled for decades in the illusion that we might not ever see again certain kinds of images (at least in the "civilized" West), these last events should ring a bell of alarm. The question then is: how did we arrive at this point? And what can those of us working in the cultural field do about it?

In the first part of this book I undertake a historical analysis that starts with the fascist phenomenon in the twentieth century, and reaches its contemporary declination (including its interconnection with the post-1970s emergence of the neoliberal doctrine), establishing a continuity that crosses over the big watershed of WWII and addresses the well documented absence of *de-fascistization* of post-war societies, using Italian fascism as the archetype of all fascisms. It has been observed that the historical pattern of Italian fascism (whereby certain pre-existing ideals and resentments became concretized in the system of governance and rhetoric that characterized Mussolini's dictatorship) appears at the origins of a wide range of fascisms throughout the world. Each has its own influences, peculiarities and heritages, but these are all united by what Robert Paxton defined as:

a form of political behavior marked by obsessive preoccupation with community decline, humiliation, or victimhood and by compensatory cults of unity, energy, and purity, in which a mass-based party of committed nationalist militants, working in uneasy but effective collaboration with traditional elites, abandons democratic liberties and pursues with redemptive violence and without ethical or legal restraints goals of

internal cleansing and external expansion.[11]

In the second part of the book I analyse fascism as a *cultural* phenomenon, rather than a strictly *political* one, including its links with the arts, cultural movements and the media. I trace the contiguity of fascism with futurism, and the heavy influence of the latter on the former in the years prior to its emergence on the political stage. And, moving forward in time, analyse the complicity of the contemporary media system – which emphasizes spectacularization and largely favours the interests of neoliberal governance – along with the cultural strategies that neo-fascist movements, specifically (but not only) in Italy, have used over the last decade to gain support and legitimacy. I argue that these tendencies evidence not a politically-structured mass movement, but rather a cultural shift to the right within a hegemonic system already in place.

In the third chapter, I disentangle issues of representation and cultural production in order to address the role of artists and cultural producers in shaping an opposition to this tendency, or their complicity with it, and give a closer look to what politics are to be found in some artistic trends. I am consciously using the terms contemporary art *and* cultural production as broad, loosely defined and somewhat interchangeable categories. This fluidity of categorization indicates that crossover occurs frequently in what we can generally call cultural industries, in art galleries, musea, internet forums, social media, fashion shows and so on, spaces in which images and meaning are created and exchanged. These are highly contemporary environments in which both the *left* and the *right* are concepts often not well delineated, characterized by being *cultural* rather than *political* categories. I also rehearse the issue of the tools at our disposal for the formation of a truly transformative power, and the heated debate on populism on the left and the politics of art. This discussion aims at asking what it means to be an

antifascist artist, along with delineating the possibilities for a truly transformative approach to art practice, in both individual and collective terms.

1. The Original "Fash"

Which fascism?

Let's start by creating some clarity around what is being referred to in talk about "fascism". There are multiple phenomena and temporalities that intertwine and overlap under this umbrella. While within the European context one finds several instances of this *thing*, I will stick to what I know best: the Italian example. After all, as history teaches us, it was in Italy that fascism rose and came to power first, and even if it only reached its full potential and deployed its most destructive effects in other countries, it was precisely the Italian model which served as an inspiration for a whole range of disastrous political doctrines. As Umberto Eco points out, it is not by chance that today we speak in general terms of *fascisms* and not of *nazisms* or *falangisms*.[12]

The most prominent of these temporalities, in terms of extension, definiteness and accomplishment, is the fascist government which unfolded in Italy between 1922 and 1943; or, to name its foundational event and its epilogue, between the March on Rome of 28 October 1922 and the withdrawal of support for Mussolini's government by the Grand Council of Fascism on 25 July 1943, followed by his arrest and imprisonment. A very short imprisonment, nevertheless, as just 3 weeks later he was rescued by the SS and led safely to northern Italy, where he established the Italian Social Republic (RSI) in the town of Salò (hence the frequently used term Republic of Salò) as a puppet state to buffer the advancement of the Allies' armies towards Germany. Less than 2 years later, he and his closest collaborators met their deaths while trying to escape to Switzerland. The history of fascism can thus be defined by three macro-moments: the fascist movement, the fascist government and republican fascism – which stretches to include its survival within post-war democracy.

Pre-war fascism and the fascist regime

On 28 October 1922, some 20,000 blackshirts from all over Italy reached the outskirts of Rome with the intention of putting pressure on the king and forcing him to assign Mussolini the task of forming a new government. It is said that some militia members marched through Rome on 31 October after such a task was given, and Mussolini reached the capital to be sworn in as Head of Cabinet. But who were these "blackshirts"? The March on Rome did not happen in a void. Certainly, the fascist movement developed among Italian youth in a context of unrest and growing revanchism that saw Italy's ambitions for control over the Balkan coast frustrated by the peace deals following the Great War, as well as its late and mostly unsuccessful attempts to participate in the scramble for Africa. However, the fundamental traits of the cultural milieu from which fascism emerged were already in place for several decades prior.

Italy was unified as late as 1861, and it was not until 1870 that its army entered the city of Rome, then the capital of the Vatican State, and future capital of the Kingdom of Italy. In a nutshell: its unification was a long and troubled process, carried out by means of a violent colonial policy of assimilation that assumed the traits of a proper civil war and resulted in an unprecedented transfer of wealth from the south to the north that left the former on its knees up until today. The cultural differences between regions that had not been under the same rule since the end of the Roman Empire were huge and many languages were spoken – even Italian was only spoken by a minority of people, usually in the urban, industrial cities of the centre-north. Although political unity was declared, the country was far from being a nation. It is no surprise, then, that shifting the focus on to the colonial effort was the first choice for the ruling class in the attempt to stabilize the country. Indeed, Italy began seeking its own glory through the establishment of its colonial policy as early as 1869, at first carried out via trading

deals, and then more and more belligerently. Dating back well in advance of fascism's emergence, Italy's colonial efforts became a necessary instrument towards the concretization of the new country's national and cultural unity.[13] Furthermore, the issue of colonialism as foundational of Italy's nationalism touched on a very sensitive point at Italy's eastern border, where the struggle to control the cities of Trieste and Fiume and the regions of Dalmatia and Istria, already of long date, had resurfaced violently throughout the previous century.[14]

To ignite a pile of gunpowder that had been growing for decades, a deep political crisis further enhanced by social unrest and a wave of strikes saw thousands of socialist and anarchist workers take control of their factories throughout the north of Italy between 1919 and 1921, in what is commonly known as the *biennio rosso* (the two red years). Both the industrial bourgeoisie and the southern agrarian class now feared for the advent of a soviet revolution in the heart of Europe. In this context, the fascist movement appeared as a convergence of frustrated war veterans of all political views, restless youth in search of political representation that was offered neither by the parliamentary parties nor by a monarchic power perceived as weak and indecisive, and the lower classes, in particular the southern farm labourers. These groups were more than keen to join fascist militias (the *squadristi*, later to be enrolled in the blackshirts who marched on Rome and constituted the backbone of fascist repression in the early years and served as colonial troops in Africa) to violently disrupt the socialist and anarchist organizations on behalf of the industrial and agrarian landowning classes, in a wave of political terrorism that claimed more than 500 lives and injured thousands in less than 2 years. The rise of fascism in the 1920s was certainly facilitated by an unprecedented wave of violence and the formation of alliances between the most powerful interest groups at the time. But it also revealed itself to be a marked cultural force, with a powerful

imaginary that was able to involve large parts of Italian society.[15] Despite Mussolini's rhetoric of rebellion, anti-establishment novelty and the overcoming of the categories of left and right, the establishment of a fascist government led, within a few years, to the stabilization of the industrial and agrarian system, and engaged in the modernization of the Italian capitalist system. Even though the rhetoric and programme of its earliest period keeps being recycled nowadays as a propaganda tool for the rehabilitation of the regime (and the figure of Mussolini), the fascist government turned quickly into a strict dictatorship that aimed at establishing a totalitarian state.[16] Its policies had the effect of reinforcing the existing structures of power around the leading figure of Mussolini, whom it celebrated as the very cornerstone of its existence. The aspiration of the regime to assume total control went as far as reorganizing time[17], with the introduction of a calendar starting from the year of the March on Rome (where the years were expressed as, say, XII E.F., meaning "year 12 of the Fascist Era"). At the same time, it made sure to have good relations with the Vatican, and instituted a capillary system of surveillance and political police to crush all opposition which, combined with a school system entirely dedicated to indoctrination, made it inconceivable to imagine the possibility of a rebellion against it, or the existence of something else. The totalitarian aspiration of fascism is evident in these policies, but it was never able to challenge any of the previously existing powers, and its vernacular character remained – up to its contemporary manifestations – its most prominent characteristic. Many of the leaders of the antifascist resistance later declared that their commitment to the antifascist cause developed more as a sort of *a-fascism*, in the sense that it emerged out of boredom and annoyance at the indoctrinating practices that they were subject to, rather than from a genuine disagreement with the government on the basis of political principle. This combination of an apparently youthful, disruptive and modernizing

force, with an all-encompassing totalitarian logic to which an alternative is impossible to imagine, also characterizes – as we will see later – contemporary neoliberalism.

Republican and post-war fascism

The Italian Social Republic (RSI), which existed for less than 2 years at the end of the war and is often overlooked as a sort of "second-hand fascism", in fact bears responsibility for some of the greatest cruelties perpetrated by the blackshirts. These excesses were driven by a mix of desperation in the face of rapidly approaching defeat, and retaliation against the increasingly successful actions of antifascist formations – by then a large constellation of well-organized forces – and would reach a level of intensity unseen in Europe for a long time. Italian soldiers and fascist militias would actively collaborate with or operate under the directives of the Waffen SS (who were now moving freely within Italian territory and constituted the backbone of resistance against the advancement of the Allied forces) in perpetrating some of the most bloody massacres and acts of retaliation against civilian populations seen in modern Europe.[18] Liberation Day is commemorated on 25 April, the day when in 1945 the leaders of the partisan formations called for a general insurrection in all the major cities of the north of Italy, and the day on which Milan and Turin, among other cities, were liberated. Many of the fascist officials were subsequently imprisoned, or had to face a similar fate as Mussolini, who was stopped by a partisan patrol on 27 April while trying to escape the country in disguise, and then killed on 28 April. His body was then crushed by an overexcited mob and hung upside down[19] from the awning of a gas station of Piazzale Loreto in Milan.[20] While the gas station no longer exists, its significance as a perennial, immaterial monument to the fight against fascism stands strong.

One of the most toxic myths with which public opinion has comforted itself for decades is that fascism was defeated. While

this idea certainly has been part of the construction of the post-war antifascist common sense, its legacy meant the inability to recognize ongoing transformations and restructuring that have been taking place in that sewer[21] since the end of WWII. Assuming a rupture, an end to *the thing* just because Mussolini, Hitler and the higher ranks of the fascist governments had been eliminated, obscures the striking continuity between the backbone of the fascist regime and the new Republican Italy. As a matter of fact, in Italy only a few hundred public officials were fired (many of whom were reinstated a few years later), and the essential chain of command within the police force remained basically intact.

The story of the corpse of Mussolini, which after a series of grotesque episodes ended up in a crypt in his native town of Predappio, is quite telling of the problematic way in which Italy has dealt since the day after with its past and its responsibilities. The town is nowadays the destination of perpetual pilgrimages of fascist scum from all over Europe, and a highly problematic project of the institution of a Museum of Fascism in a former town building adds to the controversy.[22]

One might think that after such a violent regime change a wide cleansing to rid the country of the former power would occur. Indeed, many episodes of violence and physical elimination of members of the fascist hierarchies took place, such as those carried out by the infamous *Volante Rossa* group, active in Milan from 1945 until 1949. The disarmament of the many partisan formations across Italy was not achieved without resistance – the communist component being the backbone of the whole partisan movement. Many of them did not see the elimination of fascism and the return to a liberal government as the endpoint of the armed struggle that began in 1943. The ultimate task – one that seemed feasible, given the number of militants armed and organized in military formations – was the establishment of a communist government following the example of the 1917 revolution, a process which had been interrupted by the rise

of fascism in the early 1920s, and the organized violence of the *squadristi*.

But the priorities of the leaders of the PCI (Communist Party of Italy) were others: stabilize the country to avoid the spread of a civil war (like the one that took place in Greece, for example), and present itself as a force capable of governing Italy. In 1944, with the famous *Svolta di Salerno* ("turning point of Salerno", agreed upon with the USSR), Palmiro Togliatti, the leader of the PCI, returned to Italy under the protection of the Allied armies, and agreed on giving up revolutionary aims and participating in a government of national unity with other minoritarian political forces once the country was liberated. Being that the communists and socialists were the political forces who paid, by far, the highest price in terms of repression, they decided to spend the credits accumulated during the long years of fascism and enter the existing institutions through the main door. In 1946 the new, republican government – composed by communists, socialists, Christian Democrats and liberals – approved a controversial measure, the "Togliatti amnesty", which, in the name of national reconciliation, allowed hundreds of torturers, executioners, informers and collaborators of all sorts to run free and resume their efforts within neo-fascist formations. Following this and other decrees, none of the members of the military accused of war crimes both abroad (from Spain, to the colonial wars in Libya, Ethiopia and Somalia, to the Balkans and Greece) and in the years of the RSI were ever extradited or judged.

Indeed, the fact that so many participants in the RSI were free to go in the new republican Italy ensured the continuity between the fascist government and post-war fascism. Founded at the end of 1946 by a group of RSI veterans, the MSI (Italian Social Movement) was from the outset the catalyzer of all the leftovers of the fascist dictatorship; its first leader was Giorgio Almirante, a former government official in the RSI (and secretary of the magazine *La Difesa della Razza*)[23], and it had as its initial goal the

destabilization of the new democratic order and a direct return to fascism. The MSI had candidates in the 1948 elections and was present in the new republican parliament since its very beginning, with seven deputies and one senator. The rest of post-war Italian history is far too dense and, to a great extent, too obscure to be assessed with enough precision in this context. Throughout the last 70 years, a vast galaxy of neo-fascist organizations, with more or less explicit complicity of national and international governmental agencies and secret services, enjoyed an unprecedented freedom in a country regularly shaken by mass movements and strong political tensions: at the border between the communist East and the capitalist West, and stretching at the centre of the Mediterranean area towards the troubled Middle East and north Africa, the country, one of the main industrial economies of the world, had the largest communist party in the West and at the same time a number of powerful mafia organizations with many international connections that were not strangers to some of the most bloody pages of recent history.

The 1950s saw the bloody repression of the struggles of agrarian workers in the south carried out by the mafia (with massacres such as the *Strage di Portella della Ginestra*[24]). In June 1960 Genoa's youth and workers, together with local administrators and former partisans, engaged in a diffused riot against the police, in order to prevent a congress of the MSI from happening in the city. The year 1965 saw the *Convegno sulla Guerra Rivoluzionaria* (Congress on the Revolutionary War) held in Rome, in which the most important personalities of the national neo-fascist milieus developed a strategy that put aside the attempt of destabilizing the republican order, and envisioned a collaboration with parts of the secret services of right-wing sympathies, in order to prevent the rise of the left.

From the late 1960s to the early 1980s this collaboration would take the form of a strategy that became famous as the

"Strategy of Tension", which consisted of the infiltrating of the extra-parliamentary left by underground fascist militants in order to perform the dirty job of stabilizing state power via false flag operations and terrorist attacks on train stations, banks and crowded squares. Those years became famous as the "Years of Lead".[25] The wave of over 200 terrorist attacks that took place in Italy in those years served as justification for the state's repression of political movements that resulted in thousands of left-wing and anarchist militants being incarcerated, tortured and arbitrarily killed in the streets and in prisons. The bombings of Piazza Fontana in Milan, which is considered the opening act of this strategy (12 December 1969, 17 dead and eight wounded), Piazza della Loggia in Brescia (28 May 1974, 8 dead and 102 wounded at a Communist Party demonstration) and of Bologna Station (2 August 1980, 85 dead and 200 wounded, the last terror attack targeting civilians), to name but the most relevant, were all perpetrated by fascist militants with more or less evident support from secret services – either in the planning or throwing inquiries off the tracks.

Contemporary fascist organizations such as CasaPound (CPI) and Forza Nuova (FN) – the most relevant neo-fascist organizations of contemporary Italy, which will be analyzed further in the next chapter – have direct links with some of these events. Although many media outlets tend to ignore, hide or avoid it in their reports, there is a continuity between contemporary fascist formations and what happened during these years, not only in terms of slogans, but in the activists themselves, whose shadow overlaps with some of the darkest moments of post-war Italian history. Both Roberto Fiore (FN) and Gabriele Adinolfi (one of the leading figures of CPI) fled abroad following the investigations of the 1980 Bologna bombing, only to return to Italy 2 decades later. Fiore established a network of very remunerative businesses in London – which is now the main provider of economic support for FN – where he

enjoyed the status of political refugee granted by the Thatcher government. Stefano delle Chiaie, another very prominent figure of neo-fascism, is suspected to be the mastermind behind the new alliance between the Lega Nord and CasaPound.[26]

In recent years, Berlusconi was responsible for opening the "gates of hell". After 50 years in which fascist organizations operated more or less in the shadows, the tycoon won the general election of 1994 riding the wave of a widespread resentment against politics caused by the outburst of a national corruption scandal. The *Tangentopoli* scandal, which exploded in 1992, exposed a vast network of corruption and bribery that spread across the whole political spectrum, wiping out most of the political system that had ruled the country since WWII. The Socialist Party and the Christian Democrats vanished overnight, with most of their leaders either in jail or on the run. Fresh from the congress of 1989, which marked the demise of the Communist heritage and the transformation of the PCI into a centre-left party, the new democratic left party did not manage to profit from this vacuum, which was claimed by the mastermind of the Italian media system thanks to heavy propaganda and the support of the Sicilian mafia. Completely foreign to politics, and interested only in escaping investigations about to prove the mafia's role in the building of his empire, Berlusconi seeked the support of Alleanza Nazionale (the former MSI, which in 1994 held a congress in which its leader, Gianfranco Fini, managed to rebrand the party and frame it as *centre-right*) and its well-oiled network of political relationships, and of the Lega Nord, back then a minor separatist party with folkloristic tints, advocating for the creation of a new state from Bologna upwards named *Padania*. Berlusconi got to escape jail and boost his business, and his neo-fascist allies got to enjoy the massive firepower of the empire that literally controls the quasi-totality of the mass media of Italy. Although short lived, this government was the first time in republican history that "former" fascists entered the

"control room".

Throughout the whole political parable of Berlusconi, more and more figures from the extreme right would have access to key positions and start curbing policies and rhetoric, gradually lowering the bar of what is allowed, to achieve a rewriting of history that would shift hegemony largely in their favour. In 2011 Berlusconi was removed from office because of his reluctance to fully comply with the austerity measures demanded by European financial institutions, as his base of supporters was mostly comprised of the middle class which was to be the target of such policies; in other words, his model of neoliberalism was not keeping up with the evolvement of the crisis and the restructuring demanded by other European economies such as Germany and France. His government was followed by 5 years of coalition governments led by the Democratic Party (with Berlusconi's support, because, well, he's hard to kill), which pushed further the neoliberal agenda of the EU, and got even more alienated by its own base. As a result, a political vacuum similar to the one of the 1990s opened up, and was quickly filled by the inconsistent and schizophrenic 5 Star Movement, in collaboration with the rabid, racist rhetoric of Salvini. The rest is today.

The case of Italy, which I have here briefly outlined in its main historical coordinates, certainly presents similarities and differences with an international context, and cannot be taken as fully representative. It must be noted, though, that Italy is the country in which fascism established itself. And to this day, it continues to confirm its role as a political laboratory for various forms of populism and right-wing movements.[27]

Spain is another example of how a country can neglect its fascist legacy entirely: Spain's twentieth-century history, from the brief existence of the Spanish Republic, crushed by Franco with the help of international fascism (including Italian air-power), through to the restoration of the Monarchy which rules to this day,

offers a continuous thread throughout the issues treated in this book.[28] Germany and Austria also present unsettling similarities in their incomplete *denazification*, despite the Nuremburg trials. It is also worth noting how post-fascist Germany and Austria have functioned as laboratories for neoliberalism, with the clear aim of preventing another mass phenomenon like Nazism by implementing a social transformation that would move society from a *political* ethos to an *economic* one. The assumption behind this attempted ideological transformation is that a society functioning according to a purely economic logic, in which individualism is the fundamental orientation of people's lives – thus making such a degree of identification of the citizens with the state and its leader impossible – would no longer differentiate between homogeneous and heterogeneous elements on the basis of race or other categories, which had been the basis of decisions about who was to live and who was to die under Nazism. As we will see now, this assumption was completely wrong, and as soon as half a century later, the West was already beginning to see the deleterious effects of the new doctrine.

Neo-fascism and neoliberalism: Buy one, get one free!

Having in mind the main characteristics of historical fascism, especially in its phase of government, one could think that neoliberalism and fascism are incompatible: while the latter is characterized by an extremely centralized state, and the subjects' submission to the absolute and sovereign will of the leader, in which the individual dissolves into hierarchical organizations that structure even the smallest detail of life, time and social relations, the former – as it came to be during the late 1970s, and then in the 1990s with the rise of computers and Silicon Valley[29] – places all emphasis on the individual and its desires, calling for the dissolution of almost all forms of state power and the confinement of its intervention to very basic functions

(monopoly of force and administration of certain services) in favour of a totally self-regulating market economy, in which highly productive entrepreneurial subjects and *self-made men* perform at their best to make the most out of what's available.

But this reading of both neoliberalism and fascism is insufficient, as it risks leaving out part of the picture. While a thorough discussion of economic models is not within the scope of this book nor, in all honesty, within my reach, what is most relevant for my argument is the juxtaposition of the essential cultural features of both fascism and neoliberalism, not read as *political* and *economic* doctrines, but as *cultural* phenomena. Neoliberalism, in fact, is also a model based entirely on competition, with the claim that competition is a force that leads to the optimization and rationalization of resources. It just replaces the referee: the state is gone, but the caring father is more present than ever. And this father has not shown less passion for authority than the previous one.

In the years following the beginning of the economic crisis of 2008, this model of state withdrawal has shown the tendency to replace centralized state power with several alternative and equally autocratic powers from the field of private entrepreneurship. Examples of tech giants and companies from the so-called gig economy, such as Amazon, Uber and Airbnb, exhibit some tendencies that are not in stark contrast with the model of the state as proposed by historical fascism: moved by their ambition to become leaders of their respective market fields, these companies implement aggressive strategies to eliminate competitors, and clearly aim to switch from mere service providers to market regulators up to the point of reducing policy makers to the position of adapting their policies to their own will. So long reaches the arm of Jeff Bezos (Founder and CEO of Amazon, which started in 1995 as an online book marketplace), that as of 2016 half of all US e-commerce went through Amazon, which literally sets the conditions for whoever

wants to sell online (take it or leave it: it takes weeks before any well-performing product sold on its website is replicated and sold at a lower price by its in-house brand), its web service division provides cloud computing for most of the US (from Netflix to the CIA), and is steadily taking on the biggest companies in all fields of business and research, from AI to food delivery, from the entertainment industry to small scale retail shops.[30] These multinational companies' direct influence on governance, in terms of their tendency to centralization and their unappealable character, has reached levels only dreamt of by the fascist dictatorships of the last century, to the point that in order to avoid using the services provided by the platform economy, one has to make a conscious, politically motivated and increasingly unsustainable choice, hard to justify and, to most people, just pointless.

The rise of neoliberalism and the financialization of the economy is linked to technological advancements – from the first Apple computers in California, to the app-based economy that exploded in the last decade. The great push towards control and surveillance, and the possibility of acquiring a vantage point over one's competitors (including the state) provided by the technologies developed in the last few decades (most of the time thanks to state subsidies or public research facilities) shifted the means of understanding the processes that have such a large influence on the most concrete aspects of our lives beyond the reach of the vast majority of the population of the planet. Furthermore, the tendency towards automatization (and efficiency) is a constant of the most neoliberal countries. From managing the pension system to public transports, healthcare and the progressive privatization and surveillance of public space, to the precarization and externalization of labour (for example by allowing discounts for customers that scan their own groceries) and housing[31]: every field that was previously administered by the state is now regulated by the inscrutable

"laws of the market", which happens to be a euphemism for the bigger fish law, in which the size of the fish is so disproportionate that the individuals stand no chance. Any deviation from a predetermined path of behaviour becomes increasingly difficult and suspicious, while widespread informatization leaves even the administrators of services out of control on their own tasks, and allows no deviation from a set of predefined rules.

The neoliberal system's alleged pursuit of economic growth, from which everybody is supposed to benefit, clashes with its inherent Darwinism whereby the weakest elements are destined to be reduced to mere consumers and excluded from society when they cannot keep up the pace. The market does not require people to act rationally; on the contrary, it stimulates people, from a very early age, to follow their instincts, to seek instant gratification and act irrationally by accumulating debt in order to satisfy their desires and needs (from university education to the largest flat TV screen), only to punish and induce feelings of guilt once insolvency has manifested. Such kinds of irrational desires are not too different from the level of obsession that Mussolini and Hitler were able to instigate in the common people at the apex of their power, to the point of becoming objects of desire and role models, much like characters such as Steve Jobs more recently. But at the same time, neoliberalism demands efficiency and resource optimization, which are also usually the first justifications for racist, fascist and securitarian policies. Let's not forget the infamous school tests that, during the Nazi regime, invited children to calculate how much money the state could distribute among the "normal" citizens by eliminating the disabled.[32] Another important element to consider is the punitive character that the neoliberal elites have demonstrated to consider non-negotiable. Punitive and irrational as, for example, the treatment dished out to the Greek state in the last decade. So much for the economic growth and the benefit-for-all. It is not surprising, then, that this country was the first in

the Eurozone to experience at the same time a total dissolution of the enthusiastically neoliberal left parties (with the exception of Syriza, whose extremely problematic role in the evolution of the crisis I will not discuss), and an extreme turn towards populist rhetoric, particularly with the rise of the neo-Nazi Golden Dawn party. The summer of 2015 had shown in plain sight the cannibalistic and irrational character of neoliberalism, when the German establishment preferred to throw fuel on the fire of openly fascist forces in Greece, rather than negotiating the conditions of the debt with a moderately social democratic, albeit populist, government. At the same time, the German press launched a massive offensive against the Greek people, assuming that the cause of the debt was the people's inability to manage their resources as efficiently as Germans do. This led some commentators to coin the term "economic racism" which, even if coming from a position of criticism, is problematic in itself because it ends up hiding the fact that all racism is based on economic reasons: it was born as a pseudoscience crafted in order to justify the enslavement and exploitation of part of humanity.

Instead of functioning as efficiently as it claims, neoliberalism creates a state of deep unsettlement and resentment in those who are left out of the advantages that such radical transformations cause (meaning the vast majority of people on the planet). Contemporary fascism, with its aura of anti-systemic rebellion, is having an easy game in co-opting the unrest of parts of a depoliticized society, and directing them towards the wrong targets. A task made even easier by the absolute withdrawal of the parliamentary left from any attempt to articulate a different thought, and its inability to even conceive the need to develop new forms and discourses other than the slightly more human version of the far right which has caused nearly everywhere in Europe its total collapse.

Furthermore, the purely economic and mathematical core

of neoliberalism as an economic doctrine removes any agency from those subject to its conditions, not only average citizens/subjects, but – as the case of Greece shows – also governments and transnational agencies, which are left powerless by the elevation of the economic logic to the status of dogmatic truth.

Unresolved colonial issues, and unresolved issues with race and whiteness play a significant role, in combination with the long-running tendency, typical of neoliberalism, to transform political issues into purely managerial ones to be dealt with solely by a cost/benefit logic. One such example is provided by the transformation of the approach of Italian authorities to immigration in 2017: with the rise to the role of Minister of the Interior of Mr Minniti, the country witnessed a switch from a "catholic" rhetoric, in which migrants are poor subjects in need of help and charity (obviously not unproblematic in itself), to one in which they are merely described in terms of "numbers of arrival". It is indicative that following the rise of Salvini to the role of Interior Minister, the Italian left tries to discredit his loudly iron-fist approach to migration by advertising how the supposedly "serious and professional" approach of the past government led to the drastic fall in the number of arrivals since the deal with Libya, which is keeping hundreds of thousands of people locked up in concentration camps in the Sahara desert.[33] All possible questions regarding the lives of other human beings get relegated to the background of a rhetoric founded on the sum of costs and benefits (no surprise, the first are always towering over the latter), and the state becomes the dispenser of life and death according to unquestionable calculation. This dehumanizing approach proved to be the most effective in opening the door to the re-emergence of a diffused common sense that is no longer afraid of speaking of "ethnic substitution" and "defense of the white race" without encountering much resistance in the general discourse. A rhetoric that brings to mind the *Manifesto della Razza (Charter of Race)* of 1938, which was an articulation

of ideas that had started making their way into common sense already in nineteenth-century USA[34] and that also influenced the coagulation of right-wing thought throughout in the twentieth century, including the Nouvelle Droite of Alain de Benoist,[35] – an inspiration for most of the nationalist and neo-fascist parties of the last 50 years.

2. Hegemony at Work

In the first chapter I reconstructed the historical lineage that, running throughout the last century, connects the turbulent years prior to WWI with the most recent developments of the contemporary political landscape, *de facto* closing a circle that seems to have reached a point in which the beast is biting its own tail.

Now it's time to set aside this historical reconstruction and concentrate on some examples of how hegemony is formed, and fascisms are made appealing, back then and now. Looking at the fascist phenomenon since its beginning with the lenses of cultural analysis, rather than only through political historiography, allows one to envision a field of action that goes beyond the merely political, and creates entry points for those subjects that want to carry on the struggle with the means of cultural labour. This, of course, assuming that everything is political, and nobody who cares about politics can separate their work from their politics. As we will see, the emergence of a fascist hegemony in the twentieth century would not have been possible without the heavy load of work carried out by means of cultural labour, as much as in the case of its contemporary manifestation.

Towards a fascist hegemony?

To see how the foundational ideas of fascism – white supremacy, racism, authoritarianism, nationalism, misogyny – which to many seemed to have disappeared after WWII are resurfacing within civil society[36], it can be useful to look briefly at the concept of hegemony, as developed by Antonio Gramsci. In *Hegemony and the Socialist Strategy*, Ernesto Laclau and Chantal Mouffe trace the "humble origins" of the concept of hegemony, as applied in the political sphere, back to the Russian social democracy of the nineteenth century.[37] But it is in Gramsci's *Prison Notebooks* that it

expands to describe a very complex system of relationships and mediations between the different bodies of a society. His idea of hegemony sets his thought apart from a reading of historical processes in a strictly mechanical sense, and from a reductive or authoritarian function of the ruling classes. The difference between a *dominant power* and a *directing power* is crucial in understanding the chances of survival of a given system. A successful ruling class needs to be able to exercise *domination* and *direction* at once: domination is granted by the monopoly on violence via the police and military apparatuses, while direction relies on the tools that create cultural hegemony. The existence of a strong power of direction is essential for the survival of a system, which must be perceived as desirable by those subject to it: once the battle for hegemony is lost, and a system can only rely on coercion to ensure its continuation, its fate is sealed. But, for the dominated, hegemony functions as a mere smoke screen, as the very fact that the state at least formally maintains its monopoly on violence makes this the most successful strategy for its survival.

The newspapers (today, the whole media system), all the cultural and moral institutions, the Church, the political parties, create the conditions for which the classes subject to state power structures not only do not attempt to overthrow the government, but believe that it acts in and exists for their own interest, and prevent any attempt to change the status quo by external or internal interventions. This cultural domination leads the subaltern classes to identify with a set of norms and rules, and more generally with a common sense perceived as natural rather than as a system constructed in order to maintain the status quo. In a crisis, these institutions could direct the attention and the strength of the social classes which are more subject to harsher conditions towards scapegoat categories, such as the Jewish population in Nazi Germany, or Muslims, migrants, Roma peoples or the urban poor generally nowadays.

By looking at contemporary media campaigns – such as the ones against the EU or migrants in UK tabloids, for example, or on Fox channel in the US, or other media outlets – and their influence on the general common sense (we will soon see the case of Italy) one can have an idea of the trajectory that led, for example, the German population to accept the segregation and sudden disappearance of millions of Jewish people that used to live among them. Not only the party organs and newspapers, but the whole environment of information gradually flattens out positions dictated by the most outspoken voices, which are the most self-exculpatory and easiest to digest. As we will see, art and culture are not exempt from participating in this mechanism, and can be powerful allies of the ruling class' genocidal policies.

Fascism and futurism

Fascism and futurism went hand in hand from the moment of their almost simultaneous birth. One can go as far as stating that futurism was a key inspiration for fascism ever since Mussolini got to know and appreciate the dynamism and exuberance of Marinetti – the founder of futurism – and his followers during the interventionist demonstrations organized by them in 1914 to push Italy into WW1. After then, the degree of permeability between the two movements remained notable throughout the structuring phase of the fascist movement.[38]

The restless disposition of the young futurists, and their fascination with technology, offered a dynamic ground in which the visualization of the ideals proposed by early fascism became identified with the myths of velocity, audacity and the predominance of action over thought (many of which match the ideal subject of neoliberalism: the young self-made entrepreneur). If it's true that, at least in its first decade of existence, the socialist and anarchist component was not irrelevant among the futurists – just as it was not irrelevant among the first fascists – it is also true that in the turbulent political landscape of those

years, starting from the second half of the nineteenth century, it was not uncommon to find crossovers between the extremes of the political spectrum on the basis of revolutionary anti-state positions.[39] Before the war, Filippo Tommaso Marinetti was a revolutionary socialist (just like Mussolini), and throughout his political commitment he somewhat merged a revolutionary attitude against the state and the Church, the old morals and traditions, with a strong nationalist sense. As fascism started turning more and more to the right, in the years between 1920 and 1923, the futurists found themselves being more to the left than their twin movement (albeit on very confused and contradictory positions), and tried to establish themselves as a political force in dialogue with, and able to influence, fascism. The failure of these attempts, and the definitive consolidation of the fascist government on strongly conservative and authoritarian positions, marked the return of Marinetti to a more reasonable conduct, and his dedication to strictly artistic matters. By giving up the project of a futurist political party, he pledged his allegiance to the fascist project, and embarked on a never accomplished attempt to establish futurism as the official artistic movement of fascism.[40] Throughout the following 2 decades, he was allowed to carry on his artistic career as propaganda artist of the regime (even if not always so enthusiastically as in the early days) with all the advantages that came with the position, but his power – and his movement's – was to be challenged more and more until the definitive triumph of the Nazi-like traditionalist approach against the *degenerate art* of the avant-gardes.[41]

But let's go back to the beginning. The *Manifesto Futurista* was published by Marinetti on 9 February 1909 in the French newspaper *Le Figaro*, almost exactly 1 decade before Benito Mussolini's publication of the *Manifesto di San Sepolcro* on 24 March 1919.

The name refers to the location of the previous day's meeting, at which the official birth of the fascist movement was enshrined:

the headquarters of the Association of Traders and Merchants in Piazza San Sepolcro. Many artists who participated in futurism were present at the meeting, among them Marinetti himself, who held the second speech of the day, right after Mussolini's. A few weeks later, Marinetti also actively participated in the events that led to the storming of the headquarters of the socialist newspaper *Avanti!* in Milan.

This event is described in Marinetti's 1941 manifesto "Qualitative Imaginative Futuristic Mathematics":

> Calculate the clear sum of revolutionary Victory obtained in Milan the 15th of April 1919 (the Battle of via dei Mercanti) by means of 50 Futurist poets 100, Arditi 50 early Fascist squadristi and 300 students from the Polytechnical Institute + the political genius of Mussolini + bold aeropoetic imagination of Marinetti + Ferruccio Vecchi in order to defeat 100,000 socialist-communists routed because imbued with pacifism and hence frightened by pistols multiplied a hundredfold by patriotic courage.[42]

It is not only the fascination for violence, mechanization and war – the "only hygiene of the world", as it is described in the Futurist Manifesto[43]– which constitutes the shared foundation of futurism and fascism. Misogyny appears as another key foundational element: the *feminine* appears, to the eyes of proto-fascists, as a soft, obscure and corrupting force, in stark contrast with the metal body of the man-machine that embodies the ideal subject of early-twentieth century accelerationism.[44] Marinetti's experience of a car crash served as a cathartic moment that inspired his definition of futurism; his description of the episode reveals, in a few lines, all the problematic aspects of the fascist ideology.[45]

After a night out with friends, Marinetti decides to take part in a car race in the countryside, on an impulse that he describes

with these words: "Let's break out of the horrible shell of wisdom and throw ourselves like pride-ripened fruit into the wide, contorted mouth of the wind! Let's give ourselves utterly to the Unknown, not in desperation but only to replenish the deep wells of the Absurd!"[46]

Soon enough, two cyclists come in sight of the speeding car, and Filippo Tommaso has to decide whether to run them over or throw himself into a ditch. It seems a miracle that he decides to spare the lives of the cyclists, but he finds a way to make good on the apparent contradiction with his philosophy: "O maternal ditch, almost full of muddy water! Fair factory drain! I gulped down your nourishing sludge; and I remembered the blessed black beast of my Sudanese nurse...When I came up – torn, filthy, and stinking – from under the capsized car, I felt the white-hot iron of joy deliciously pass through my heart!"[47]

He is then rescued by a group of passing fishermen and friends of his, his pride not shaken a bit by the humiliating experience. The symbolism of this account is telling: the ditch stands for the feminine, dirty, polluting and obscure substance that a man has to go through, but eventually find a way to escape from, whose attractive power is connected to his earliest childhood memories. Even better for the sake of Eurocentric exoticism if the corrupting agent is the black body of a native woman from the colonies. As if in a dream of conquest, in which one can only either possess or be possessed, the man has to turn himself into the metallic body of the machine and penetrate the voluptuous body, only to then escape the dreadful challenge posed by the subject he wants to dominate with the help of his powerful will and his male colleagues.[48] Masculinity (established by rejecting the attractive weakness of the female body) and audacity play a crucial role; these are the dominant powers that bend technology to its own will. The establishment of the machine as a part of the living organism and its ability to perform reproductive tasks via the further development of industrial technology would set

humanity free from its dependency on women.

Masculinity, misogyny, colonialism, racism, authoritarianism, rejection of the human for technology, the preponderance of action over thought, the glorification of death as instrumental in the rebirth of a new man: these aspects are futurism and fascism in a nutshell, which at this point we can define respectively as the *aesthetic* and the *political* sides of the same coin. I have written *political* in respect to fascism, but as Umberto Eco argues, this political side never managed to express a fully accomplished political ideology: "Contrary to common opinion, fascism in Italy had no special philosophy. The article on fascism signed by Mussolini in the Treccani Encyclopedia was written or basically inspired by Giovanni Gentile, but it reflected a late-Hegelian notion of the Absolute and Ethical State which was never fully realized by Mussolini. Mussolini did not have any philosophy: he had only rhetoric."[49]

Which is one of the reasons why *fascism* functioned as a container for all the colonial, nationalist and misogynist tensions that were circulating within Western societies for centuries prior to its emergence as a political movement, and why it became a matrix for other similar, totalitarian ideologies – including neoliberalism. We will now see how these tropes, and a strong emphasis on the aesthetical, are far from gone in contemporary manifestations of fascism.

The glamouring of CasaPound

Bringing the concept of hegemony to the contemporary situation, one can catch glimpses of the functioning of a hegemonic machine that is dangerously flirting with the most reactionary tensions and public anxieties, pandering and exploiting fears of poverty and recession. An example of the production of hegemony is provided, in this context, by the work that the mainstream media seem to carry out in normalizing fascist groups. The case of CasaPound Italia (CPI) offers an example of this tendency.

CPI emerged into broad daylight in December 2003, when its militants occupied an empty building on the Esquiline Hill, in the centre of Rome, a stone's throw from Termini central station, in the heart of a neighbourhood populated by dozens of different ethnicities.[50] Certainly not the first fascist hideout in Italian post-war history, the technically illegal act of occupation with which they claimed their space marked a significant rupture with the "law and order" façade that characterized the fascists of the previous decades. To be fair, this was not the first illegal occupation established by fascist militants, but the previous ones (also in Rome, named CasaMontag and Foro753) had brief existences and were mostly demonstrative actions.

Nevertheless, as soon as CPI squatted the building in Via Napoleone III, the local and national press suddenly discovered a very palatable side of fascism to play with. The act of illegally occupying a building belonging to the Regione Lazio (the regional authority whose capital is Rome) gave the fascists an aura of rebellion, of antagonism and non-conformity[51] which allowed CPI to appeal to a young generation of subjects frustrated by a decades-long economic crisis (as much as a supposed "crisis of values") that appears to have paralyzed Italian society since the early 1990s. With the given differences, one can imagine a similar kind of frustration among the youth being channelled by the emergence of the early fascist formations in the twentieth century. Early news reports from the first days of CPI describe it as a mix of subculture, rebel music genres, and voluntary and non-profit activities, and express a sort of decontextualized, genuine wonder for the eclectic reference figures that its leaders crafted as the cultural ground of the movement, validating the self-crafted depiction of anti-systemic force, alternative to both establishment and left-wing antagonism.[52] The names of, among others, poets Gabriele D'Annunzio and Ezra Pound – whose daughter sued the group for the allegedly inappropriate use of her father's name – and also Plato, Julius Evola, the futurist

painters Giacomo Balla and Filippo Tommaso Marinetti – as we have seen, deeply implicated in the very definition of the fascist phenomenon since its earliest days – Dante, the singer Lucio Battisti, W.B. Yeats, Carl Schmidt, Afghan guerrilla leader Massoud, Codreanu and *en passant*, of course, Benito Mussolini, all mixed together to form a *Pantheon* of – to say the least – dubious coherence, are painted inside the entrance of the building. Magazines and widespread publications such as *L'Espresso* rushed to publish photographic reportages and articles about this new phenomenon, neglecting the prominent, extremely violent aspects of its activities and publishing apologetic pieces of writing and imagery with the clear result – if not the intent – of diluting the more problematic aspects of the movement, which include, as we have seen earlier, its ties with the *stragismo nero*, right-wing terrorism of the 1960/70s.[53] Once questioned by the press whether or not they would define themselves as fascist, CPI's answer was a masterpiece of ambiguity: "We are the fascists of the third millennium".[54]

Whichever millennium they like to claim they belong to, their rhetoric and postures are imbued with something like a *futurism for dummies*. It is not uncommon to hear of initiatives being labelled "turbo-futurist night watches", or the framing of physical assaults as "kicks and futurist slaps"; this passion emerges in the name of one online forum, named *Vivamafarka* after the protagonist of Marinetti's novel *Mafarka il futurista*. So much is their fascination for the intrepid gesture that they cannot help but perform it in-house as well, such as with the so-called *cinghiamattanza* (which could be translated as "belt-slaughter") that takes place at the concerts of the *nazirock* band Zetazeroalfa (the punk-rock band founded by CPI's leader, Gianluca Iannone).[55]

Fascism to fashion

So much is the attention that CPI pays to its aesthetic appeal,

that in recent years it even started its own fashion brand: Pivert. Rigorously made in Italy, its clothing is designed to appeal to a general public, nothing that would out you as a fascist straight away – like a swastika or a celtic cross – but when worn in the right context and by initiated people it speaks a subtle code language. It is a sense of belonging readily available off the shelf. The names of their clothing pieces exude nostalgia for colonialism, as they are inspired by the Roman Empire provinces, some of which were also the object of the fascist regime's attempt to establish the modern version of its past glories (*Cyrenaica, Assirya, Mesopotamia, Bythinia, Dalmatia* and so on) and on their website you can also find a crash course on each one of them, in case you were too busy beating the reds to attend your history class. But I might sound too biased in describing the aspects of this enterprise, so I will just quote the brand's website:

[Pivert is the] French word for woodpecker, vulgar Latin piculus, diminutive form of the classic word picus. In Indo European mythology is the bird of fire and lightning. The red color mark it apart. The sound it produces is similar to the wood when it is rubbed to start the fire. We often find it associated with war gods: Zeus-Jupiter, Ares-Mars. And from here comes the concept of woodpecker as #semiDio (demigod). He lives on Earth, with other human beings and in tune with them. But at the same time, the Pivert man, is a dynamic man, who knows what he wants, entrepreneur himself.[56]

A perfect fascist, masculine man forged with fire; a futurist artist, enlightened temperament living among common men; and a self-made entrepreneur, on to the next challenge. Again, from their mission:

Pivert is belong without losing originality, make look as a

lifestyle. Not an elitist man. Does not withdraw to upper floors of a skyscraper to observe from the top down. Engineering, architecture, are just some of the arts with which he expresses his will. Pivert Man gets his hands dirty but cannot stand the mass standards, things of all and for all. Appreciate the good company of the few, art, design, food, beauty, sports. This is the MISSION of Pivert. Giving space to Man.[57]

One can have an idea of the kind of man they mean by having a look at the website: the models are a mix of regular cool with expensive tattoos from the fancy neighbourhoods of Rome, and thugs you would not want to meet in an empty alley at night, as they "get their hands dirty".

The common denominator? A slightly threatening, masculine pose, enhanced by the fact that they all wear sunglasses in the shots. And speaking of code language, in May 2018 (during the phase of negotiations that led to the formation of the new government) Matteo Salvini was photographed wearing one of their jackets at a football match in Milan. The extremely curated media role of the leader of the Lega Nord sent a direct message to the neo-fascist formation: don't worry, I'll make sure your concerns are addressed as agreed.

The F-word

The tendency to treat the resurgence of fascist phenomena with a benevolent eye in the media could seem a somewhat innocuous practice, if its effects did not include a dangerous discrepancy between the facts and the perception of the phenomenon. This allows media outlets to craft and deploy a functional narrative that, totally disconnected from the factual reality, rather serves to condition public opinion. One such strategy implies the use (or rather non-use) of the *F-word*,[58] where acts of violence performed by full-blown fascist subjects against migrants, LGBTIQ and left-wing individuals, for simply *being what they are*, are described

as driven by insanity, jealousy, momentary rage or simply as the *unexplainable* acts of lone wolves. The openly fascist cultural milieu in which these subjects operate, as shown by their political activity with fascist groups, their social media profiles, littered with memes featuring Mussolini and Hitler as well as photos of them with Nazi flags (the cases in which members of police and armed forces are caught in such behaviours are very frequent),[59] their hate speech, fascist clothing and tattoos...all these things, according to the media, do not constitute sufficient evidence to call them fascist terrorists.[60]

On the morning of 3 February 2018, Luca Traini, a right-wing activist in the small town of Macerata, drove around the town in his car, firing a gun at every black person he could find, and injuring six. After a couple of hours chased by police, he stopped in front of a monument celebrating Italy's fallen soldiers, and performed a fascist salute wrapped in an Italian flag before being arrested. While held in custody, he did not show any remorse, and claimed that his gesture was done in revenge for the brutal murder of Pamela Mastropietro, an Italian teenager with drug-related problems, in the same town a few days earlier. A group of alleged Nigerian drug dealers, classic boogeymen among Italian public opinion,[61] are under investigation for this tragic case that shook the life of the small provincial town, and Traini was now taking justice into his own hands by indiscriminately targeting black people.[62] In the subsequent debate that developed nationwide, barely a month prior to the latest political election, Italian public opinion found itself discussing the subject of whether or not the country hosts *too many immigrants*, instead of – as one might expect – whether the country hosts *too many racist terrorists*. The acts of a person who would perfectly qualify as a terrorist were somewhat justified by the idea that the Italian society is "exasperated" by the presence of too many immigrants[63] (a justification mildly counteracted by a general "condemnation of all violence"). Once again, the tormented body of a woman was

instrumentalized to justify the implementation of racist policies and the establishment of a poisonous rhetoric which has started to have dreadfully concrete effects for an ever-growing portion of the population, and this time did not claim any innocent lives by a fortunate coincidence. The media's shameless disregard of any discourse addressing the racist turn that things are taking – including the complete absence of any acknowledgement of, let alone reflection upon, Italy's colonial past from media and education – is a serious issue preventing Italy from avoiding the descent into a very dangerous position. The fact that the totality of the voices engaging in this debate equated *black* to *immigrant* is also a sign of the widespread refusal of the possibility that one can be at the same time black and Italian, a sign of the fallacies of thinking even in the field of those who would condemn racist acts.

This is also true regarding its contrary, as an exaggerated depiction of neo-fascism can lead to schizophrenic accounts that downgrade, say, Traini's gesture one day, and inflate a marginal right-wing public demonstration the day after. Following a very heated end of 2017, on 7 January 2018, CPI held a much publicized national demonstration to commemorate the fortieth anniversary of the deaths of three MSI activists that occurred in 1978.[64] On that occasion, activists from all over Italy came to Rome to participate in a big march that was intended as a sort of demonstration of strength, 2 months before the general election that seemed fated to usher CPI into the Italian parliament. Photographs of the event circulated widely, depicting what at first glance appeared to be an *endless* parade of fascists stretching down the whole length of a very long street. The feeling is impressive, as they march in silence, in orderly rows of seven, disciplined and with a martial aura. A second analysis of the photos, rid of emotional charge and dedicated to the count of actual persons in the frame, reveals that the actual number of people attending what was an extremely important occasion for the whole national movement,

held in the capital and highly publicized, did not exceed 700. The demonstration of force that held headlines for a few days, throwing liberal commentators and left-wing politicians into a panic, would be deemed a half-baked gathering in the context of any left-wing event organized in a mid-sized provincial town. The carefully designed choreography and the aesthetics of the march won CPI a big mediatic success despite the weak attendance.

Why does everybody fall for *the fash*?

Many words can be spent and many analyses could attempt to understand the reasons behind this benevolent eye. I want to point out three reasons that to my mind are central. The first can be found in the ambiguous character of these phenomena, which makes them difficult to read and situate. In his 1979 book *Cultura di destra* (Right-Wing Culture)[65], the Italian Jewish scholar Furio Jesi describes right-wing culture as one in which the past is a sort of "homogenized paste, able to be modeled in the most useful way, in which the existence of non-negotiable values is declared and indicated with the capital letter" (e.g. "Homeland", "Family", "Nation", "Tradition", "Values"),[66] which then function as perfect catchwords in the media. Ambiguity seems to be a winning strategy for this highly hierarchical movement: by not allowing the media to frame them unequivocally as fascist, CPI managed to attract ever-growing attention and legitimization before the warnings by the left-wing social and political movements against the extremely violent practices put in action by its militants started to make the news. Other attempts to induct the younger generations into the neo-fascist rank and file were carried out in the 1970s with the establishment of *Hobbit Camps*[67] for young neo-fascists. The need to intercept youthful unrest and re-shape it into a base of activists, who are better when young and "pretty", was very strongly felt by the leaders of a *New Right*. They hoped to thereby resist an impressive wave

of politicization among the young left-wing movements that had led to a level of conflict unseen in Italy since the end of the war.[68] Back then, perhaps to a degree unwitnessed before, your way of dressing and behaving, your musical choices and nearly every aspect of your style and behaviour would unequivocally qualify you as either a left-wing *revolutionary* or a right-wing *reactionary*. By playing the same game as the many organizations on the left, the neo-fascists tried to acquire a level of legitimation that would guarantee their survival outside of the secret plots that polluted the political life of post-war Italy[69] and Europe in general.

The second reason may at first glance appear banal, but it is perhaps the most directly influential: few journalists have *actually* suffered violence at the hands of fascist thugs.

Certainly not in the numbers and the modalities as the usual targets of their actions: journalists are predominantly *white, Italian, middle-class men*. As such, they are not routinely the target of "futuristic" bravado such as the *bangla tours* (the nickname for nightly punitive raids carried out by young FN militants against members of the Bengalese community in the east of Rome), nor beaten or stabbed as often happens to militants of left-wing social centres and political organizations in street fights in which they are strategically outnumbered.[70] Proof of this fact is that, whenever journalists are the subject of some sort of mild episodes of violence from the far right, the liberal media falls into a state of hysteria and for a few days the headlines cry of a fascist scare as if the country was on the verge of a military coup. One might say that many times it is also not their own fault: most of the journalists from local outlets simply *lack the tools*, and the will, to understand fascist violence altogether, let alone gain awareness of their role, and nine times out of ten they simply copy and paste the reports provided by the police. In this way, they reproduce the format of the "opposing forms of extremism", equally to be rejected, and providing a reading of the political clash through a "law and order" logic, which is

where the third reason comes into play.

Indeed, a deeper systemic implication must be acknowledged: the neoliberal media thrives on spectacularization. Nothing sells as much as violence and sex, and in order to maintain the flow of content at a profitable pace, there is no room left for a narrative that would require some sort of deeper understanding. In this sense, the neoliberal media cannot have a different agenda than neoliberal business (to which it is, of course, only a profit opportunity).

A business that needs the constant return to a state of "business as usual", and in order to do so it must make sure that the receivers of its product are not in the mood to start questioning things too much. Therefore, fascism is named as such only when it can be splashed across the headlines of papers to increase sales. That is, when it does not trouble the worldview favourable to the big media corporations, and when it can be dismissed again after the point is made, the "antifascist virginity"[71] of this or that party, politician or body of the state is reassessed, and "foot soldiers" can be sent back to their usual task of terrorizing the weak and fostering the war against the poor. The correlation between the long-term effects of this strategy on common sense and the increase in episodes of violence against weak subjects and left-wing activists is, in my opinion, very evident. The two examples which I described took place only a few weeks apart from each other, and are just two of the most recent episodes of this decades-long strategy.

If only cars could fly

We are now approaching Elon Musk, the exuberant contemporary entrepreneur who shares many similarities with another exuberant character that we have seen before: Marinetti, the artist-turned-futurist-pilot. We already saw Marinetti's car crash in slow motion. I will now fast forward to the present, and use the recent sending into space of a Tesla car by Musk's

SpaceX agency as the entry point to analyze his figure in relation to contemporary neoliberal hegemony.[72]

But let us proceed with order: the beginning of the twentieth century saw the explosion of aviation, both as an industry and a set of striking technological advancements, and as a concept that the masses, who were used to considering their feet forever glued to the ground, received with the utmost excitement. The field of aviation quickly became the canvas on which to paint epic heroes, men defeating the laws of nature with bravery and a little dose of insanity.

Whoever had the chance to get close enough to an airplane in those days could perceive the unreliability and fragility of those machines, consisting basically of crafty automobiles with wings attached. Surviving a long-distance flight could be attributed to luck more than anything else, and the bravery of the early pilots was measured according to how they managed to postpone their epic death by crash. It is not surprising, then, that both fascism and futurism jumped on this new field wholeheartedly, with masculine impetus. Futurists were delighted by the opportunity offered by the fastest and most dangerous machines available to experience in their own bodies and minds the ecstasy of overcoming the limits of the human body, which their paintings, sculptures, poetry and happenings tried to evoque by means of stylistic innovations, loudness and subversion of all rules. The dream of the fusion between man and machine seemed at hand, and flying became an outright symbol of modernity.

Fascist propaganda, too, made wide use of aviation, both before and after the establishment of the fascist government in Italy. One of the most famous stunts of all time was the flight of the poet Gabriele D'Annunzio (one of the leading figures of early fascism and the embodiment of the ideal fascist man) over Vienna, on 9 August 1918, in which he led a fleet of aircraft, modified for long-distance flight, over the Austrian capital (then in the last months of conflict with Italy) in order to drop thousands of flyers

with the Italian flag and an invitation to surrender. Because the poet did not have a flight licence, a plane had to be modified in order to allow him to fly a machine driven by another pilot.[73] The gas tank was then shaped in the form of a seat on which D'Annunzio was sitting throughout all the 7 hour, 1000km long flight, most of which was over the territory of a nation at war. The modified seat was named "seggiola incendiaria" ("incendiary seat"). The significance and the success of the *folle volo* (crazy flight, as it was named) in terms of propaganda was huge, both in Italy and abroad. By then, fascism as a political movement was not yet formally existing, but the broth of culture that figures such as D'Annunzio, Marinetti and Mussolini were stirring, by means of this and similar stunts and provocations was soon to be coagulated into the form of a structured, political force. D'Annunzio remained one of the most influential figures of the fascist movement until and perhaps even after his death in 1940.[74]

Some 15 years later, there was another example of an epic flight that impressed public opinion worldwide, and was used by the propaganda machine of the regime: the *Crociera del Decennale* (Cruise of the Decennial, in reference to the anniversary of the Italian Aeronautical corp), a celebratory mass crossing of the Atlantic Ocean that took place in 1933. Led by Italo Balbo, one of the first fascists and most important men of the regime, a fleet of 25 aircrafts left Rome and reached Chicago for the occasion of the Universal Expo of that year, and successfully flew back to Italy after a flight more than 18,000km long. The flight, following other similar enterprises carried out over the Mediterranean and another crossing of the Atlantic Ocean reaching Brazil in 1930-31, was the longest and most successful attempt of its kind, and constituted a powerful achievement which fascism could spend both at home and abroad in its own self-portrait as a world leading industrial and military power, and home to a people that would not be second to any other in terms of audacity.

The rhetoric surrounding the commercial space industry also evoques a heroic present in which capitalist avant-gardes are paving the way for humanity's next phase – be it the trivial goal of selling rich tourists a zero-gravity experience, or the much more ambitious vision of making possible the colonization of a whole new planet. The two leading companies in this field are Virgin Galactic, born from the mind of all-encompassing tycoon Richard Branson, and SpaceX, founded by Elon Musk.

Both aviation and space flight are defined by an aura of mythology, and by a powerful ideal of modernity. They share the pretence of offering a solution that, by being objectively out of reach for most people (both in terms of the scientific knowledge required to fully grasp its mechanisms, and the possibility of experiencing it) creates a separation for a restricted class of initiated to the mysteries of flight; and on the other hand, it satisfies the desire for order which fascism promises, by hitting an imaginary "reset" button that allows us to start anew and forget the past and its unbearable heritage.[75] Twentieth-century fascism promised the masses to get rid of centuries of (perceived) humiliation of Italy, from the "barbarians" who followed the Roman Empire, to the European powers that colonized the peninsula until its final unification in 1861, from the weak and late colonial policy, to the *mutilated victory* that followed the war in which Italy felt deprived of the Balkan's shore promised to it by England and France for its help in the war. The twenty-first century space race, on the other hand, bears the promise of resetting the frightening conditions of postmodernity, with its environmental disaster, the failure of the neoliberal order to deliver that "end of history" that seemed already gained after the fall of the USSR. As in an off-world colony commercial from *Blade Runner*, we can again start imagining to leave everything behind: crisis, war, global warming, racism, insecurity, globalization, all issues that we are objectively more and more clueless about. After having brought this planet's system to the point of no

return, neoliberal capitalism promises to give humanity a second chance on a faraway world where we will look back at Earth with a mix of regret and pity for the mistakes of the fools who did not manage to make the best out of capitalism. We can give in to fascism now, because we are going to reset all, once we are living on Mars. This also serves as a good illustration of the effects of the powers of hegemony I was describing at the beginning of the chapter: while the declared intent is to "provide humanity a way out" of the environmental disaster[76], it is very likely that most of those who write tweets praising Elon Musk as a quasi-saviour of mankind would not have any possibility of covering the prohibitive costs of a return ticket to Mars' colonies.

But going back to our Starman, who we left driving a Tesla on its trajectory towards Mars' orbit, it is interesting to note the highly aesthetically charged nature of this gesture. With no real purpose other than the self-celebration of the ego of the company's master (which grandly echoes the megalomania of the futurists), the car is instead loaded with references to popular culture that appeal to a wide, yet very geographically, racially and class-bound, audience. Of course, the whole enterprise of safely landing a rocket on Earth after the successful delivery of a heavy load into orbit means, in Musk's own words, "game over for other operators of heavy-lift rockets", thus providing an insight into the aspiration to eliminate competitors typical of the neoliberal enterprise. Not only competition is at stake here: is there not also a stench of colonialism in the whole affair of being the first to cross a certain frontier (in his case, the declared target is establishing a human colony on Mars, thus appointing himself as a *whole planet's ruler*)? Surely, since the cold war, the space race has been raging and absorbing significant slices of the state's budget (whatever the state, whatever the economic and political system), so this is nothing new. Not to mention the fact that modernity is heavily intertwined with the colonization of the planet. This is the colonization of space, of the market

and the consolidation of a hegemonic order all at the same time. And the very essence of the subject who is replacing the state is highly indicative of the nature of neoliberalism: a private entity (thus profit-oriented), led by an egomaniac character with a passion for all things tech (no matter their ethical or moral implications),[77] and with the declared intent of ferrying humanity to its new phase is now at the forefront of the quest for space, outperforming the state at a game which no one could imagine challenging as recently as the turn of the century (NASA is now contracting from SpaceX to supply transportation). Yet, without centuries of state-fuelled research and investment in the field, nobody would be able to do any of what SpaceX, whose CEO takes credit for it, did.[78]

One last detail, perhaps the most indicative of the totalizing nature of the present ideology: on the circuit board of the Tesla roadster shipped to space, one sentence has been imprinted (in English only): *Made on Earth by humans*. This is the most odious aspect of the whole affair. In fact, these five words express capitalism's aspiration to present itself as a unifying force that represents the whole planet, overcoming all differences and is inherently bound to democracy. It can be even read as a first evocation of the establishment of a category of *planetary nationalism*, in a moment in which the dream of colonization of the solar system tickles the appetites of the industrial classes: a nationalism that, just as every nationalism, pretends to speak for the totality, but only represents the interests of a restricted minority. If the Marxian motto that *history repeats itself, first as a tragedy and then as a farce* is true, we have to at least grant some dignity to the *Golden Record*[79] and its effort to depict humanity and the planet as a more complex ecosystem (even if still unilateral and ideologically charged), when considered next to the inane rhetoric of this Bruce Wayne knock-off. When the rocket aims at the planet, the idiots look at the car.

3. Here Comes the Artist

Why art, of all things?

In a famous passage from *The Work of Art in the Age of Mechanical Reproduction*, Walter Benjamin proposed that the spectacularization of politics brings about fascism.[80] Benjamin was referring to the growing momentum that figures like Hitler and Mussolini had gained from a manufactured charisma but with a simple glance at the West today, one would easily find a confirmation of this. Moderate attitudes and thorough analysis are not the most popular today, and consensus seems to go in the direction of the one who makes the best use of rhetorical artefacts – the louder the better – regardless of any factual considerations.

But this is not entirely new. Already during the French Revolution, performativity started gaining an ever-growing weight in politics, as its convergence with theatre started to become more and more evident. As mentioned by Paul Friedland in the book *Political Actors*[81], after 1789 some of the most influential public figures and members of the legislative assembly either received private acting lessons, or were dramatic actors themselves, and the decisions of the assembly were more and more influenced by acts closer to theatre than political reasoning, with paid groups of "claqueurs" in the audience inciting for or against legislative measures.

Both politics and theatre greatly changed in those years: actors and politicians started representing abstract roles, and the parliament went from being the embodiment of the nation to a body that spoke on its behalf. It is perhaps in the bourgeois parliament, as the place for the resolution of political disputes, that the representation of dissent began to substitute dissent itself.[82] With the growing spectacularization, the emphasis grew on the *acts* of the performers at the assembly, rather than on

the *actions* of the citizens[83], and this professionalization of the politicians brought about the figure of the spectator (both of theatre and, most relevantly in this case, of *politics*), relegating it to the role of uninfluential observer. And, judging by the exponential increase in the number of newspapers, magazines, pamphlets, satirical publications and political commentators, the media of the time greatly embraced the new spectacle.[84] The ultimate degeneration of this process is the puppet theatre we witness today, in which the characters are superficially depicted as members of a "caste", divided in supervillains, heroes, dumbasses, clowns and so on, which makes them so easy to love or hate that any real political discussion gets flattened in violent and brief flames. The characters, for their part, make all possible efforts to be as accommodating as possible, appealing to authenticity while hiding the nothingness of their stature behind carefully-crafted avatars who thrive thanks to their claqueurs, in this case hordes of Twitter bots. Welcome to the representation of the representation of politics.

A parallel development can be said to have taken place in the case of mass political gatherings throughout the nineteenth and twentieth centuries. In the capitalist industrial economy, the main strategy in labour struggles was the strike, a confrontational practice in which the workers, sometimes joined by their families, abandon their workplaces, thus stopping the process of accumulation of surplus value. After the decline of the industrial economy, at least in the economies most advanced in the transition to a post-industrial model, the strike has been replaced by the *demonstration*, a *representation of conflict* which used to be linked to the strike but nowadays takes place on its own and has become the main strategy in labour and identity politics. The term *demonstration* itself indicates the act of showing something, the evocation of strength that the working classes can exert, but is always an exception, usually very limited in time and space. In an anticlimactic progression, we arrive at the

ultimate, edulcorated stage of the aestheticized political action: the *flash mob*. These kind of acts, either organized to be such, or so labelled by the media in order to dismiss the genuine political will of the participants, constitute the least radical and more liberal expressions of participation, too far from *political action* – like a strike or a blockade – and too close to an *aesthetical gesture* – as a like on Facebook – to really worry the establishment, which sometimes even encourages and participates as a proof of goodwill in addressing the issues raised.

But let's make our way into art. In his book *In the Flow*,[85] Boris Groys describes how the very concept of "art" itself, as a thing separated from life and supposed to be contemplated, also came about in the days of the French Revolution. Groys explains that the revolutionaries decided to expose the wealth they found when they stormed the palaces of the Parisian aristocracy and instead of destroying it, organized exhibitions of their luxurious belongings for the people to see. This act brought about an aestheticization of the past regime, and aestheticization, Groys argues, is a much more radical form of death than iconoclasm. In any case it is clear that art, as a field, has been heavily loaded with a transformative potential since its very birth. In a moment when the spectacularization of politics seems to have reached its peak and neo-fascism has been able to reinvent itself, from a group of *stragisti* and coup-plotters, fascinated with death and purity of race, to a highly trendy phenomenon, does art still have the revolutionary potential Groys describes? Can a contemporary artistic practice have a role in shaping a different hegemony?

Mythbusting: The arts as a bastion of progressiveness

As with the tale of the defeat of fascism at the end of WWII, there is another tale that needs to be debunked: the one that sees the arts as an inherently progressive environment. Perhaps since the crusade of the Nazi party against the "degenerate art" that led to the shutting down of the Bauhaus, and on the wave of politically

committed art that emerged in the Western Bloc around 1968 (which is commonly referred to as *cultural marxism*[86] by the right), speaking of the world of arts and culture as a hideout for reds seemed to be at the same time a rallying factor for the right, both in and out of power, and a reassuring tale for the left.

As we have seen before, the links between fascism and neoliberalism are not only present in their economic and social policies, but also when it comes to aesthetics and the arts. If we acknowledge that a large part of the neoliberal infrastructure today *is* fascist (think about the implementation of concentration camps and deportations for the exploitation of surplus populations[87], for example, or of the technology developed in the context of neoliberal business models, which contributes to and stimulates practices of mass surveillance and atomization in labour and life), and that the apparatuses involved in the generation and circulation of the aesthetics and the discourses that we call *art* are necessarily part of this infrastructure, we have to address how these apparatuses and the discourses they produce contribute to the reproduction and articulation of the current hegemony and its steady trajectory towards the extreme right.

There seems to be, in a large part of the contemporary art world, a certain kind of disregard, like a feeling of distrust, towards both didacticism and political activism. An art that shows too much ethical commitment is easily met with the critique of being ideologically charged, and read as propaganda. The hype of "political art" since the beginning of the 2008 financial crisis, which has seen a significant, genuine participation of artists and cultural workers in protest movements, (re)sparked the interest of art institutions and galleries in politics but didn't seem to cause any major shift in the artists' approach to their own politics, let alone *actual* politics.

This attitude comes in part from the training provided in art schools, where a hypercritical, detached and "neutral"

standpoint is often encouraged, following the logic that once the tools of analysis and the vocabulary are assimilated, the artists can choose what degree of political radicality to apply to their work. A standpoint which nonetheless does not aim at challenging the current economic system (if anything, it is a tool towards pursuing a place in the most remunerative side of the "knowledge-based-economy"), but rather focuses on the aesthetical and conceptual aspects of art practice necessary to achieve the professionalization of the field largely pushed by neoliberal reforms like the ones that followed the Bologna process. The result is an education that does not form critical minds in the arts (as in all other disciplines), but armies of skilled professionals in competition with each other, developing an artistic process usually unable to go beyond the limits of the sophisticated, white, well-mannered, self-referential, boogie-art crowds of the Western capitals. And that is dedicated to the reproduction of such social classes.

But mostly, it is an attitude deeply integrated in and sponsored by the infrastructure that produces and sells art. As art students and young artists soon learn, an outspoken attitude towards opening up new spaces for speculation that really challenge the present state of being might boil down the enthusiasm of collectors and gallery owners, as it leaves – at least since *ideology* and *propaganda* became bad words – very little space for mystification, and for profit. Even more so in the scenario described by Hito Steyerl in her book *Duty Free Art*,[88] in which the fluctuations of the art market are determined by shady trading practices allowed by freeport art storages, extra juridical grey areas to be found mostly near airports, in which artworks are stored, permanently "in transit", out of public scrutiny. Locked in a "secret museum of the internet era...a museum of the dark net, where movement is obscured and data-space is clouded", art loses even its faint social function as a device supposedly able to touch, move and fulfil the souls and

minds of museum visitors exposed by its life-changing power, and becomes just another object of financial speculation. Like weapons, drugs, livestock or CO_2 stored in green bonds, works of art are left at the disposal of big investors that operate in an economic and juridical loophole symptomatic of the decline of the nation state.[89]

These secretive warehouses are not the only art-related scenarios where the effects of neoliberalism are evident, and it would be naive to think that the top of the pyramid does not influence its lower passages, down to the smallest bricks. As in a trickle-down effect, national museums and large galleries end up partnering with dubious regimes[90] and being part of very remunerative speculations, in a global economy dominated by neoliberal financial mechanisms that pushes for a diversification of resources leading necessarily to obscure territories. And these institutions influence, in turn, their smaller counterparts, which can do little, albeit the alleged good intentions of some of them, to challenge the very system that at best keeps them afloat, and at worst turns them into part of the rank and file of fascist groups.

The emphasis on optimization of resources, profit making and the detachment of the works of art from their politics (hence from the environment they would potentially transform), are fertile grounds for topics easily exploited by right-wing discourses, and even an excuse to give this discourse a platform. The ever-growing need of novelty in the spectacle-craving neoliberal economy leads, for example, to an excessive focus on technology which, as Marina Vishmidt puts it, "has always been the greatest legitimation, and naturalization, paradoxically, of the desperation of the commodity to remain ever-new, ever-same. It's no different for curatorial and institutional agendas functioning in that very same economy, driven by those same subjectivities it generates".[91] In the last decade, contemporary art enthusiastically put itself on the fire line between the tech world and the common folk, with the ambition to illustrate to

the latter what it means and what it will *look like* to live in a world with an increasingly blurry subjecthood, in between human and machine, where politics is not a necessary element of life anymore – and sweeten the pill.

To name an example, one of the most trendy topics at the intersection of technology and art is the blockchain technology and cryptocurrencies. Much like the futurists, who believed that industrial machines were going to forge a new humanity and had so much in common with the totalitarian dream of fascism, a large part of this bitcrowd seems to have an unshakeable faith in the liberating power of technology, by itself capable of restructuring society, deterministically reshaping humanity as a network composed of billions of interdependent nodes, in which any bit of information would be common knowledge, shared and validated by the net itself.[92] As in an accelerationist dream, the new prophets of the intangible foresee, for example, the undermining of the banking system via the issuing of many cryptocurrencies with no central authority. This, they claim, will bring about a truly democratic way of exchanging resources and information worldwide at the speed of light. As a result, the nation state and its borders will dissolve, as the network takes charge of its primary functions – validating the identity of its citizens and ensuring a trustworthy environment for economic transactions – thus creating a perfect neoliberal scenario, in which we free ourselves from the oppressive, bureaucratic state, without touching any of the structural aspects of capitalism.

The artists that partake in this fascination like to clothe themselves with an aura of underground and avant-garde, copy-pasting left-wing keywords like horizontality, borderlessness, participation, direct democracy, and mixing them with less politically connotated ones like decentralization and transparency. In a time in which the left wing seems to lack an idea of what its future needs to be (culturally even more than politically), this rhetoric appeals to the need for novelty, but with

a logic of management of resources and decision making typical of a business-oriented mindset and supposedly unavoidable: "the only way out is the way through". The problem with these practices that reproduce an anarcho-capitalist vision in which improving the channels of distribution ensures enough efficiency to overcome politics and sustain a stateless society, is that their foggy aesthetics hide the fact that the neutrality of technology is a dangerous myth, and that such technologies can only serve any good purpose within a historical, political and social reading of their potential. If politics is removed, if the myth of neutrality is implemented, if the substantial economic and hegemonic conditions stay the same, then those tools can only strengthen the dominant ideology, leading to a "liberation" that includes only the white subjects who have the possibility, and the will, to participate and normalize, from a position of power, this technocratic, god-like entity of atomized, self-possessing nodes à la Matrix.[93] The other billions, what Marx called *surplus population*, living in the rural areas, in the slums, stuck in poverty and slavery, sieged by climate changes enhanced by millions of servers processing 24/7 will only face another, insurmountable segregation wall.

The act of promoting a novel, apparently apolitical art is thus not as harmless as it seems at first sight. As Larne Abse Gogarty shows in her article *The Art Right*[94], the alt-right is very aware of the potential of an ambiguous aesthetics and it exploits post-internet tropes to recruit confused liberal souls. In her piece, in which she discusses the scandal around the London gallery LD50, an example of a gallery that went all in in its support of openly fascist art, she quotes a Google document, found on the political section of 4chan, titled *Westhetica*:

...the anonymous author suggests "synthesising"...futuristic themes with a classical greco-roman base...80s retro neon vibrancy...postmodernism and distinct irony alongside new-

age imagery. These are all classic vaporwave and post-internet associated tropes, and the document further stresses the idea that 'emphasis on aesthetics helps separate the notion of white identity from fat spergs/skin heads and dorky cuckservative stiffs in order to gain wider appeal'. The aim is to 'appeal to the more Bohemian type of people...They could be drawn in by the aesthetics and then get redpilled with incremental exposure to the ideas of the alt-right'. *This stands as an attempt to rebrand the culture typically associated with white supremacist movements in order to assist in the goal of entryism among the young, white bourgeoisie.*[95]

As Gogarty acknowledges herself, the case of LD50 and of that particular event is an extreme one: the gallery, located in one of the most important targets of gentrification in the UK[96], organized in 2016 a series of very secretive conferences on neoreactionary thought featuring right-wing speakers like "Iben Thranholm, Peter Brimelow, Brett Stevens, Mark Citadel and, finally, Nick Land"[97] which relied heavily, for its organization, on the network of American neo-Nazi websites such as Amerika. org. In what seems like a direct result of these plotting sessions, a later show displaying alt-right aesthetics, tweets by Trump and a number of other alt-right influencers and neo-Nazi internet imagery was organized, with the clear intent to glorify the milieu in which neoconservative and alt-right discourse is fabricated and legitimized by the use of the contemporary art's "aura". However, as the discussion above suggests, promoting alt-right artists does not necessarily have to be part of the agenda. Aware or not, deliberately or not, the resources the art world has to offer, like financial support, spaces and a certain credibility when it comes to the elaboration of discourse, can very easily go to the right. The issue of (along with certain figures involved in) the LD50 controversy, for example, came back to the spotlight in the case of the 6th Athens Biennale, titled *ANTI*, a similar

case of an art institution that, to say the least, refused to censor fascist behaviour within its own "circle". The Biennale proposed itself as "an agonistic space hosting different approaches on how to deal with ominous tendencies in politics and culture". However, when confronted by artist Luke Turner[98], one of the invited exhibitors, about the participation of Daniel Keller in the Biennale, an artist with an ambiguous approach towards antifascism, who recently defended the abusive behaviour online and life-threats by two other artists against Turner himself, the curators of the Biennale, while remarking their antifascist artists' CVs, washed their hands and pulled the good old "we need to encourage discussion, and if you want to censor another point of view, you're not welcome" argument.

Comrade artist, we have a problem.

Can left-wing artists hijack hegemony?

The question of antifascism is inextricably linked to the more general question of the transformation of what exists. By means of revolution or reform, art or politics, or whatever other means one might find suitable, transformation is not only possible, but constantly happening. Therefore, once one has embraced the struggle to fight fascism in the arts, the effort needs to move from the defensive to the offensive and turn its attention to capitalism as a whole. As a widespread slogan says, "antifascism is anticapitalism", and this is equally true in the arts. Assuming that the former can exist without the latter is a liberal fantasy that only adds grist to the mills of neoliberalism. The issue of defining what the left is (or rather, what the left needs to be in the twenty-first century and beyond) is part of the process that will overthrow capitalism.

The goal of influencing the formation of hegemony is not the progressive improvement of life conditions in the context of a transition to a generic post-capitalist system (which, in the given conditions, runs the risk of being far worse than the

present capitalism), but the creation of a force that is able to seize the means of production and build a new system through a discontinuous rupture with the state of being. Gramsci's understanding that without a control over hegemony no revolution could be possible, and his insistence on the need of educating the working classes and forming intellectuals organic to them is still very relevant.[99] Especially considering that we live in a world in which the revolutionary option has vanished from the political horizon, and politics has lost most of its mobilizing and representational power to cultural representation: political actors are perceived and play according to schemes that are no longer political, but cultural.[100]

Again in *Duty Free Art*[101] Hito Steyerl claims that the balance between *political representation* and *cultural representation* is leaning more and more strongly towards the latter and for this reason little power is left in representative institutions such as parliaments and governments. In comparison to the vast power exercised by obscure, non-democratic financial institutions, representative institutions have no force. This causes a sense of frustration or alienation due to the loss of that faint spark of hope of being heard, via participatory processes such as elections, which is met by another feeling of estrangement caused by the increasing layering of meaning of cultural representation. This frustration and alienation can lead people to seek refuge in voices that claim to be able to shut down the mess, abolish representation altogether and make things plain and simple. "Frustration" is not an excuse for choosing the wrong target and turning into a fascist, of course. But nobody becomes a fascist overnight because they consciously decide to do so. Most of the people that end up conforming – and adding momentum – to the current fascist-leaning hegemony might be repelled at first by an openly racist discourse. While scared by a daily barrage of misinformation about "ethnic substitution" and "lowering wages", their attention is attracted by other cultural artefacts:

radical but ambiguous imagery, appealing but not necessarily coherent aesthetics, and discourses that are non-conventional, perhaps a bit uninhibited and certainly intriguing. In short: something that makes them feel part of a larger "fashion". Fascist marketing campaigns like Generation Identity and Defend Europe, for example, are very good at bringing together neo-fascist militants and common sympathizers, who are attracted by the sleek logos and websites, or the quilted jacket uniforms, aspects that normalize these fringe groups.[102] A rebranding lesson clearly learned from CasaPound.

Once the strategy of the right wing to challenge the left at its own game, i.e. the cultural field, is detected, and the continuity between culture and politics becomes evident, we must accept the challenge. If we take up the gramscian proposition of the role of the intellectuals operating within the working classes, and eventually emerging from their ranks in order to develop a power able to direct hegemony in their favour, we also have to come to define how this is done by means of cultural production and, it goes without saying, by art.[103] Ultimately, the question is whether or not, as artists and generally cultural workers, we can still act on this theory, and how.

There is a trend of thought in the "cultural left", which proposes that populism is not necessarily positive or negative. What makes populism negative is the goal pursued by the political forces deploying this strategy. Chantal Mouffe is one of the main proponents of this argument, and she quotes the success of Corbyn in the UK and Sanders in the US as examples of successful populist strategies.[104] The idea is that developing a left-wing populism is a winning strategy to counter phenomena such as CasaPound, the American alt-right and similar political groups that have little to do with classical political reasoning, but rely mainly on the "curated" dissemination of cultural artefacts to stir pots of unresolved and unaddressed issues like white privilege, patriarchy and colonialism, until eventually the

smell becomes so strong that it starts coagulating and raining faecal matter on a completely naively unprepared society.

For the advocates of populism, in order to gain momentum against the right wing, the left should evoke their own emotional leverages, and rally as many left-leaning people as possible under appealing, easily understandable keywords that aim at uniting the ranks along a border that separates "us" from "them". The idea certainly has its charm. After all, it was not the reading of *Capital* in our teenage years (if any of us actually read it) that got us all to dedicate time and energy to grassroots organizations and forms of collective action. However, we weren't moved to mobilize politically by *The Battleship Potemkin* or by listening to militant hip-hop either, and educating our theoretical base by scrolling infinite lists of memes on Twitter alone won't bring the revolution any closer. Where this road becomes slippery, in my opinion, is that the very essence of populism, its tendency to overlook specificity for an easier and broader understanding, can easily result in a lack of depth and nuance that will be determinative once it is time to propose a concrete alternative to fascist and neoliberal governments. Don't get me wrong: I believe that there needs to be a strong antagonism against fascism. But the line along which this antagonism runs might not always be as clear as we would hope it is. And that goes for many other categories of class and identities. Populism can flatten the understanding of crucial matters that require a higher degree of articulation in order to be turned into successful political strategies, while activating a powerful emotional charge that can easily obscure reason and lead to dangerous modes of interacting with the world. The example of the 5 Star Movement in Italy should serve as a warning: the party, which was able to bring together a large share of disaffected and unrepresented individuals under the extremely vague banner of "the people against the caste", always lacked a clear political vision and even bragged of being an "apolitical movement", refusing the label

of "party". When in power, it necessarily turned to the right, pressured by the decisively right-wing Lega Nord. Because of its need to find an identity, it picked the one that needs the least effort to articulate.

Simplicity is a good strategy for the right wing, which has no real analysis or solutions to offer, but a simple, dualistic depiction of the world: either we let our community rot by the assault of some external agent, or we bring it back to the golden age in which *our people* dominated the world, and race, gender and labour *nonsenses* were invisible. This is why the right generally finds it easier to unite and reach its short-term goals. It gives people the impression that their interests are the same as those of their leaders. The very essence of the right wing, and ultimately fascism, is the subjugation of the human being and its mind. A strategy that simplifies things, that resorts to "ideas without words"[105], or that produces abstract concepts and *makes the spectator believe* that they have understood the deeper meaning of something is no good among the left wing. If we are to engage in populism, we must be careful: a radical attitude with a superficial knowledge of complex themes can be easily built, and just as easily hijacked by some smarter masterminds. A relatively successful example of this being the right's campaign to have Marx himself declare that "immigrants are the reservoir army of capitalism" (and thus that immigration should be opposed, as it lowers the salaries of the white working class) and the degree to which it is capable of polluting the discussion within parts of the left itself.[106]

On the other hand, a left that acknowledges its own rule should have in its foundational DNA the task of articulating a thorough description of an extremely complex, material world.[107] Grasping the complexity of the world will be the first step towards changing it. Each division within the left should aim at offering a deeper, more encompassing picture of the world. Maybe this is where art comes in, maybe art, because of the

way it triggers thought and evokes emotion, has the potential to stimulate the imaginative power that the left desperately needs in order to end the impasse of this historical moment, and to propose ways to shape the systems to come.

In *The Communist Horizon*[108], Jodi Dean expressly critiques this approach to politics. Dean finds that an artistic approach is more counterproductive than functional to the building of a mass revolutionary movement. She argues that "some activists and theorists treat aesthetic objects and creative works as displaying a political potentiality missing from classes, parties and unions. This aesthetic focus disconnects politics from the organized struggle of working people, making politics into what spectators see." And again, the "celebration of momentary actions and singular happenings – the playful disruption, the temporarily controversial film or novel" contributes to the cultural shift of political expression from the street to the gallery. This gives the art crowd the chance to feel radical and to ignore the contradictions between their class and the rest of society.[109] Micropolitical actions, practices of self-cultivation and individual consumer choices do not carry the same political potential as an organized mass movement. Self-cultivation and micropolitical actions reinforce and revive the circulation of capital. Turning the political body into the body of a spectator reinforces the spectacularity of the political gesture, reducing it to a marketable asset in a neoliberal regime. A regime that is able to assimilate and subsume everything, action or product, that can be understood by it. Any transformative potential is then stripped from the gesture, reducing its effect on any political struggle, existing or to come, and reducing it to a commodity or fashion statement in the eyes of its detractors or potential supporters.

This argument suggests that one should abandon the pretence that one can affect politics with art. Art should be abandoned for the organization of struggles, education, collective empowering

and daily work on structures aimed at replacing the existing system. Just as I had to agree with the claim that art has the potential to trigger an imaginary necessary to the overcoming of capitalism, I find myself in agreement with this line of thought as well. The inability of art to transform radical and revolutionary potential into political power is evident, at least when such playful disruption relies on artistic practice alone and happens within the boundaries allowed and crafted by neoliberal institutions: we cannot hope that our task as "political artists" ends by organizing events that fall into this category.

And yet, it is obvious that this field cannot be abandoned, and that a balance must be found. As artists and cultural workers we must find ways to react to the current situation, while at the same time developing a depth of analysis and thought that will be able to become a propositive force in the struggle for what necessarily comes after. A show that took place in September 2018 in the gallery KOW, in Berlin, constitutes a hopeful example of a practice that firmly reacts to a contemporary situation and does not escape the responsibility of art. The show was titled "Was euch am Leben hält, ist, was bei uns zu Asche zerfällt" (*The Fuel of Your Lives Becomes Ashes in Ours*) and the accompanying statement explained that, following a period of neo-Nazi riots and diffused aggressions against non-whites that took place, the month prior, in the small town of Chemnitz in eastern Germany (formerly Karl-Marx Stadt):

> …KOW has changed its programming on very short notice and put together an exhibition to throw a spotlight on the swing to the right in Germany. The gallery and the contributing artists want to take a stance at a time when political – and, for more and more people, everyday – life is turning into a nightmare. We want to stand with all those who fight back against this development.[110]

Featuring works of German artists produced since the assimilation of East Germany into the unified German capitalist state up until the present day – an issue that many preferred to consider resolved with the fall of the wall – the curators call the viewers to directly relate to a situation that takes place here and now, activating their political responsibility and making space for a radicalization of their politics and their way to see and interact with the reality surrounding us. But mostly, it courageously breaks the self-assumption that sees contemporary art as incapable of reacting to the here and now without becoming some sort of activist propaganda, and it does so by curating a show that strongly situates the role of artistic practice in the middle of a political landscape much bigger and more complex – yet locally situated – than the one that galleries are used to showing. It might be just an episode in a much larger and structurally hostile environment, but this might be the kind of compromise to be looked for.

When institutions are brave enough to take a step back and let political voices emerge, right-wing politicians start screaming their slurs against the ideological reds in the arts. It is usually a good sign. In this light, the following paragraph from the exhibition text seems like an appropriate reminder for those wanting to engage:

And what about the art world? Its people have come to the realization that what they do tends to exacerbate rather than mitigate social disunion as long as it is part and parcel of an economic machine that helps redistribute wealth from the poor to the rich. The worst they can do is close their eyes to this reality. They must confront the issues more vigorously than in the past and abstain from serving up symbolic fixes for disruptions that are in fact systemic. This will require a steadfast refusal to cater to a politics of cultural pacification that puts critical avant-gardes on the stage to prove that ours

is an open society.[111]

Agreed.

The selfie is mightier than the artwork

One final note on being a politically committed artist. If both the ideas that art has a transformative potential *and* that it can't be a substitute for politics are true, then politics, art and life can't be separated. Being an artist does not exclude one from also being a political subject in a society, whatever one's status. It might seem an obvious statement but it can be complex to navigate while dealing with issues of cultural production.

There is in the present moment, obviously, a right wing that resorts to strategies that we are used to associating with the left for the creation of common sense. The New Right embraces cultural representation with the goal of getting rid of *cultural Marxism* by confusing meanings and struggles in order to legitimize its own agenda: for example, the claim by the most extreme right-wing movements of protecting the right to *freedom of expression* is traditionally a claim of the left.[112] So deep is the reach of the intellectual short-circuit around this issue, that people who oppose fascist gatherings and contest right-wing politicians in their public appearances are accused by liberals and the mainstream media of "directing public attention" to them. This while broadcasting the same racist groups and individuals and allowing them to perform their own self-victimization, which means that they cannot be criticized publicly without an accusation of an assault on freedom of expression. Basically, a self-fulfilling prophecy.[113]

A freedom of expression which means, it goes without saying, that they can disseminate all their racist, homophobic and misogynistic rants without consequences. This trap of freedom of expression, intended as a sort of unquestionable *licence to kill* like in a James Bond movie, is such a strong, toxic narrative

that it has permeated the liberal left to such extent that the institutional left wing rushes to express solidarity with the right whenever they are opposed at public events. Even personalities of the cultural world of whom a deeper level of analysis would be expected inexorably fall for it. A recent example involved one of the most praised political artists of this decade, Ai Weiwei, who recently defended the choice of taking a selfie with AfD politician Alice Weidel with the following words:

> I don't believe that differences in political views or values between people should act as a barrier in communication, ...My efforts are in tearing down those boundaries. Alice Weidel is a democratically elected politician and has the right to freely express her political views. Although her views are completely the opposite of mine, no one has the right to judge her personal life...If you cannot tolerate free expression, your political views are even more terrifying.[114]

So much for the political artist. Mr Weiwei – along with whoever aspires to have a publicly recognized voice in political matters, that is, matters that embrace a collective scope – should, in my opinion, consider the weight that his words have, which is no less than, if not more than, that of his art. If Weiwei can't tolerate criticism for taking a selfie with a member of a party of white suprematist, racist holocaust deniers – which reads as *political endorsement* – then he should have chosen a different career, or stuck to less problematic and equally remunerative gallery art. As they say, *if you can't stand the heat, leave the kitchen.* You don't want to run the risk of finding yourself cooking in the kitchen of CasaWeiWei.

4. Can Art Kill Fascists?

In this historical moment, characterized by what appears to be a reprise of fascism among large segments of our societies, artists and all those invested in the creation of culture more generally cannot neglect the political impact that their work has in a broader context. The fact that relations became exponentially more complicated and multi-layered over the course of the last century – a process that will only continue to accelerate in the future – and the fact that the choices we will have to make in our work are difficult to predict cannot function as excuses to pretend that one's contribution is unimportant. In fact, the contrary is true. It is the grey areas of the production of meaning and consciousness that offer the right wing the chance to direct public consciousness towards reactionary stances.

We need to continue to study and deepen our understanding of mechanisms and processes through which meaning is established. We need to keep studying fascism in its entirety, starting from its nineteenth-century roots (and even earlier forms of racism and patriarchy), and moving through its transformations in post-war society, including its echoes in the neoliberal doctrine. If we want to aspire to understand its contemporary manifestations, and not be taken off guard by the apparent contrast between its antiquated ideas and cutting-edge strategies, we need to gather as much knowledge as possible. And we also have to go deeper in the analysis of these new manifestations, including and maybe paying special attention to their aesthetic strategies – I'm thinking of the right's powerful use of meme culture, for example.

And whether or not that's a road worth going through for the left, we need to combine our observation of the present with an in-depth study of what came *first* in order to identify what will come *next*.[115] And we also need to find ways of disseminating this

knowledge. After all, historically, the first target of neoliberal budget cuts – even before the arts – is the field of education. It might seem a commonplace, but an uneducated populace is easier to control.

There seems to be, at least among the more politically aware circles both in activism and critical theory, a certain awareness of the trick that the right wing plays on the rest of society. What is lacking is often the capacity to articulate this trick for the rest of the people who would not necessarily go Nazi if they knew where this thread leads. Art might be a way to achieve this articulation, but the discourse surrounding it and its goal cannot keep being so elitist anymore, and developing along the same conventional lines dictated by the art market.

As critical as this moment is, political awareness on the part of artists should be present in all historical moments. Making art, as much as any other activity, is always an inherently political activity, and the illusion that the past decades delivered – that actions can be separated from the context in which they take place – contributed to the present state of affairs. But if this "state of emergency" is something that, as it would seem, gets people on their feet and pushes them to act differently, then we ought to ride this wave and call for an exceptional effort. In the hope that this effort doesn't end once the nearest dictator gets out of office. As one sign spotted at an anti-Trump protest in January 2018 read: "If Hillary was president we'd be at brunch".

Yes, and that is precisely the problem.

The great expansion of the possibilities granted by contemporary communication media blur the boundaries between an artist's work and their persona, but also between what is canonically defined as art and what has an influence on the general public. The power that was once somehow exclusive to art and high culture is now shared and perhaps overshadowed by other, more immediate and hugely accessible forms of expression. This means that an artist's political effort

can no longer be – if it ever was – confined to their work and the context in which it is shown, but has come to permeate all aspects of their public output. In the same way, one's decision on whether to participate in the electoral process or not does not represent the totality of one's involvement with politics. In this public arena, one of the most difficult artefacts to dismantle is the argument of "free speech", which increasingly captures the minds and hearts of people whose sole experience of the violation of their right to free speech consists of being banned on Twitter. How to avoid being silenced by the same, seemingly democratic demand that for the past 2 centuries belonged to the left? For one, by making sure that free speech does not mean impunity for whatever is expressed, be it online or in "real life". Just as politicians such as Trump and Salvini use platforms like Twitter to engage in highly provocative declarations[116] and push the boundaries of what is accepted, right-wing sympathizers in the cultural world often use the same platforms to introduce toxic narratives through seemingly innocuous, ironic and light-hearted content, with a touch of progressiveness, which they too defend advocating their freedom of speech.

I cannot offer a complete and detailed vision of what an antifascist art practice looks like, but any reasoning that wants to move in that direction must be based on the assumption that art, as it is conceived now, is a predominantly white, bourgeois invention, and as such it is at the same time highly exploitable for right-wing purposes, and criticizable for being far from the lower classes that fascism pretends to speak for. Because of that, a whole range of questions and problems should become an integral part of such artistic process: why is it being made? In which context is this taking place? Does it help to problematize the issue or does it flatten it? Does it challenge or reinforce existing structures of power? Is it inclusive or exclusive? Does it take into account the materiality of historical processes? Who benefits from it?

Eventually, antifascist art (or an antifascist practice of any kind) is one that recognizes that its purpose is to communicate something about the world, about humanity, and people's struggles, acknowledging different standpoints, responsibilities and possibilities. It is not an art that speaks for those who cannot speak but rather one that opens spaces for them, so that they can speak for themselves. It does not become mired in redundant discourses about itself, but rather focuses on the vital forces outside of art. An antifascist art is a form of art that doesn't lose contact with the world, and makes space for whatever is non-fascist, never giving up on being generous, as knowledge without generosity results in hate.[117] This means also being able to detect fascist behaviours coming from our own circles, to call them out and to be brave in opposing them and offering solidarity to the victims of such behaviours. Being an artist does not make you untouchable, and as the art world turns fascist, more and more artists are exposed and persecuted by fascists. Whatever you are doing, you have to put your ass on the street. Call it art, call it cultural production, call it whatever you like, but while doing it, remember that you need to be an antifascist. There are many ways to do this, and the task of whoever decides to oppose fascism is to try and find the best way to do it. Be an artist, be a writer, be a plumber or be a football player, but don't forget to do it as an antifascist, first and foremost. It might not sound like much of an advice, but it's the only premise on which any discourse can and should be built upon.

Endnotes

1. Unitedagainstrefugeedeaths.eu. 2018. *List of Deaths*. [online]. [Accessed on 26/11/2018]. Available from: http://unitedagainstrefugeedeaths.eu/about-the-campaign/about-the-united-list-of-deaths/

2. Harris, C. 2018. Woman the sole survivor after migrant trio "abandoned" in Mediterranean. *Euronews* [online] 18 July 2018 [Accessed on 17/8/2018] Available from: http://www.euronews.com/2018/07/18/libyan-coast-guard-deny-the-accusation-they-abandoned-migrants

3. Bianchi, L. 2018 I razzisti italiani sono usciti di testa per le 'unghie laccate' di Josefa. *Vice* [online] 23 July 2018 [Accessed on 17/8/2018] Available from: https://www.vice.com/amp/it/article/ev8v4e/unghie-laccate-migrante-josefa

4. Camilli, A. 2018. *Josefa ha le unghie laccate perché nei quattro giorni di navigazione per raggiungere la Spagna le volontarie di Open Arms le hanno messo lo smalto per distrarla e farla parlare. Non aveva smalto quando è stata soccorsa. Serve dirlo? https://twitter.com/doluccia16/status/1020679077504733184.* [Twitter]. 22 July 2018. [Accessed on 17/8/2018]. Available from: https://twitter.com/annalisacamilli/status/1021065000348155904

5. Laino, G. 2018. La blogger che ha diffuso la foto di Josefa con lo smalto stipendiata da CasaPound. *Giornalettismo* [online] 25 July 2018 [Accessed on 17/8/2018] Available from: https://www.giornalettismo.com/archives/2669868/francesca-totolo-casapound-josefa

6. Tondo, L., Giuffrida, A. 2018 Warning of "dangerous acceleration" in attacks on immigrants in Italy. *The Guardian* [online] 3 August 2018 [Accessed on 25/8/2018] Available from: https://www.theguardian.com/global/2018/aug/03/warning-of-dangerous-acceleration-in-attacks-on-immigrants-in-italy

7. I will use the term *West* in different contexts throughout this book, usually to refer to the large group of countries that found themselves under the hegemonic umbrella of the United States and the Anglo-Saxon world in the post-WWII geopolitical scenario, in opposition to the communist bloc. However, I acknowledge the problems that the artificial category of "West" poses.

8. The former Italian PM Matteo Renzi from the Democratic Party – a derivation of the PCI, which itself was once the largest communist party in the West – appropriated the old anti-immigration slogan which characterized the refusal of immigration by the extreme right in previous decades: "We don't have the moral obligation to accept whoever comes here, but we need to help them in their own countries" (Balmer, C. 2017, Italy's Renzi urges end to "do gooder" mentality on migrant influx, *Reuters* [online] 7/7/2017 [Accessed on 8/6/2018] Available from: https://www.reuters.com/article/us-europe-migrants-italy/italys-renzi-urges-end-to-do-gooder-mentality-on-migrant-influx-idUSKBN19S2PB). The MP Serracchiani stated that "rape is an odious crime, but it's worse when it's perpetrated by an immigrant" (Camilli, A. 2017, Migration and sexual abuse in Italy, inside a toxic news cycle, *Open Democracy* [online] 11/10/2017 [Accessed on 8/6/2018] Available from: https://www.opendemocracy.net/5050/annalisa-camilli/toxic-news-italy-migration-sexual-abuse). And former Sen. Esposito, from the same party, said that the NGOs carrying on search and rescue operations in the Mediterranean "have an ideological approach for which it's all about saving human lives" and "we can't afford that" (Anon, 2017, "Per alcune ONG il tema è solo salvare vite umane": bufera sul Sen. Esposito, *La Repubblica* [online] 3/8/2017 [Accessed on 8/6/2018] Available from: http://www.repubblica.it/politica/2017/08/03/news/esposito_ong-172275786/?ref=RHPPLF-BH-I0-C8-P4-S1.8-T1).

9. Anon. 2018. "We'll rule for 30 years" says Salvini. *Ansa* [online] 2 July 2018 [Accessed on 17/8/2018] Available from: https://www.ansa.it/english/news/2018/07/02/well-rule-for-30-years-says-salvini-2_c4b2e95c-9265-49a7-88c7-f1f 02e67fc8b.html.

10. O'Toole, F. 2018. Fintan O'Toole: Trial runs for fascism are in full flow. *The Irish Times* [online] 26 June 2018 [Accessed on 25/8/2018] Available from: https://www.irishtimes.com/opinion/fintan-o-toole-trial-runs-for-fascism-are-in-full-flow-1.3543375?mode=amp

11. Paxton, R. O. 2005, *The Anatomy of Fascism*, New York: Vintage Books.

12. Eco, U. 1995, Ur–Fascism, *The New York Review of Books*, [online] Volume 42, Number 11 [Accessed 8/6/2018] Available from: https://www.nybooks.com/articles/1995/06/22/ur-fascism/

13. To quote an example: the speech *La Grande Proletaria si è mossa* ("The Great Proletarian has moved"), a collage of nationalistic mythology, self-praise of Italy's supposed cultural and moral superiority, and self-victimization. It was written in 1911 by the influential national poet Giovanni Pascolito to justify the military aggression against the Ottoman Empire with the aim of securing control over Libya. The text, which passionately advocates the establishment of a "virile" colonial policy, was widely diffused and even became part of the primary school curriculum.

14. Since the beginning of the twentieth century, Italy has enforced a violent process of italianization of its border regions, with the excuse that they historically belonged to the Republic of Venice and are, thus, culturally Italian (regardless of the fact that the Republic, spanning over 1000 years, was a highly cosmopolitan state). Acts of revenge against the agents of this process took place at the end of WWII, with hundreds of killings of Italian fascists and other im-

plicated people at the hands of antifascist formations that were mostly composed of communists and soldiers from Tito's army. Since 2003, Italy celebrates the "Day of Memory" on 11 February to commemorate a supposed genocide of Italians, claiming that thousands of innocents were killed and thrown into the *foibe* (underground caves typical of the Karst region) simply for being of Italian ethnicity. Every year on this occasion, conveniently celebrated only 2 weeks after the International Holocaust Remembrance Day (27 January), the authorities memorialize the victims with great honours, while the mediasphere is flooded with distorted information and hundreds of miscaptioned photographs, with the aim of building a counter-hegemony by providing a "right-wing holocaust" to distract from Italy's active participation in the genocide of Jews. (Wu Ming 1, 2015. *Cent'anni a Nordest*, Milano: Rizzoli). A comprehensive documentary on the many instances of Italian colonialism was produced by the BBC in 1989 (directed by Ken Kirby), and is available on Youtube (Solari, R. 2012. *Fascist Legacy da History Channel* [online]. 11 September 2012 [Accessed on 9/6/2018] Available from: https://www.youtube.com/watch?v=2IlB7IP4hys&t=543s).

15. On the aspects of fascism that have their foundation in social psychology, the essay by George Bataille *The Psychological Structure of Fascism* (Bataille, G. 1979) constitutes a fundamental reading, which would go beyond the scope of the topics discussed in this text. In the essay, the author compares fascism and the Islamic Caliphate on the basis of their ability to create a sovereign power in the absence of a pre-existing power: in the case of the Islamic Caliphate, a force able to establish a highly structured civil and religious power within less than a century out of a fragmented ecology of tribal and nomadic populations that were scattered across vast, mostly desertic areas; in the case of fascism, a

force that managed to channel a set of primal impulses and tendencies into a structure able to fight for world domination within a period of scarcely 2 decades.

16. Whether or not such efforts were successful can be debated, but fascism did not achieve the same level of assimilation of the nation's life into state structures as Nazi Germany. The concept of totalitarianism, furthermore, remains a poorly defined one, and its use in later years has come to overlap with the concept of dictatorship *tout-court*. Often the intent is to discredit this or that totalitarian regime, as in the relativistic catchphrase: "Both Nazi Germany and Soviet Union were totalitarian regimes (and thus equally evil)". Bellassai, S. 2018. Quale fascismo, quale antifascismo – Note sul Museo di #Predappio [online]. Giap! 8/6/2018 [Accessed on 11/6/2018] Available from: https://www.wumingfoundation.com/giap/2018/06/note-sul-museo-di-predappio/

17. An attempt that, to be fair, is not unique in the case of fascism: the most famous case is the decimal calendar adopted during the French Revolution, in which the organization of the time was greatly reshaped, with 3 weeks of 10 days each, days of 10 hours and hours of 100 minutes. The reform was definitely abandoned in 1802, only to be employed again, for 18 days, during the Paris Commune of 1871.

18. Over the 40 years Italy attempted to colonize Africa, the populations of Libya, Somalia and Ethiopia had already been subjected to such treatment. They were the test subjects for practices such as the first-ever aerial bombardment (Johnston, A. 2011. Libya 1911: how an Italian pilot began the air war era, *BBC News* [online]. 10 May 2011 [Accessed 8/6/2018] Available from: https://www.bbc.com/news/world-europe-13294524), the use of gas (for which Italy faced international sanctions that forced the regime to adopt a policy of "autarky"), mass deportations (in 1929 half of the population of the Gebel el-Achdar region in Lib-

ya was deported to 13 concentration camps in the desert), and the indiscriminate killings of non-combatants in retaliation for actions of resistance, such as the *Yekatit 12* massacre of 1937, in which some 30,000 Ethiopians were murdered in a pogrom carried out in Addis Ababa by Italian military and settlers in retaliation for the attack that almost killed the viceroy of Ethiopia, Rodolfo Graziani (Wikipedia, 2011. *Yekatit 12* [online]. [Accessed on 8/6/2018] Available from: https://en.wikipedia.org/wiki/Yekatit_12). It often goes unnoticed, even by the Italian left wing, that the first antifascist partisans were Ethiopians defending their country, some of whom later participated in the liberation of Italy. Awareness around such topics in Italy is close to nonexistent, to the extent that Graziani, one of the biggest war criminals of the twentieth century, was recently honoured with a mausoleum in the cemetery of his town of birth, Affile, near Rome (Anon, 2012. Italy memorial to fascist hero Graziani sparks row, *BBC News* [online]. 15 August 2012 [Accessed 8/6/2018] Available from: https://www.bbc.com/news/world-europe-19267099). A list of fascist camps of different kinds (imprisonment, concentration, labour and so on) is available online. (*Campi Fascisti* [online]. [Accessed on 8/6/2018] Available from: http://www.campifascisti.it/mappe.php).

19. One common act of mockery directed against the far right in Italy is the simple inversion of any image depicting political adversaries, recalling the fate that fascists used to suffer in Italy.

20. A lengthy filmed documentation of the event is available on Youtube (Giacomo Milazzo, 2011. *Piazzale Loreto* [online]. [Accessed on 9/6/2018] https://www.youtube.com/watch?v=wOCecmSa-M0).

21. As a famous Italian commonplace had all the fascists being "thrown in the sewers" after the war.

22. A thorough elaboration of this issue, the history of Musso-
 lini's corpse, including an in-depth analysis of the proposed
 project is the subject of a lengthy post on Giap! Wu Ming 1,
 [2018]. Predappio Toxic Waste Blues, Part 1, *Giap!* [online].
 4 June 2018 [Accessed on 8/6/2018] Available from: https://
 www.wumingfoundation.com/giap/2017/10/predappio-
 toxic-waste-blues-1-di-3/ An English translation will soon
 be available on the same website.

23. Wikipedia, 2004. *La difesa della razza* [online]. [Accessed on
 16/6/2018] Available from https://it.wikipedia.org/wiki/La_
 difesa_della_razza

24. Wikipedia, 2007. *Portella della Ginestra massacre* [online]. [Ac-
 cessed on 14/8/2018] Available from https://en.wikipedia.
 org/wiki/Portella_della_Ginestra_massacre

25. Several articles on this very dense period of Italian History
 can be found in English on Libcom.org (Libcom. 2004-2018.
 Strategy of Tension [online]. [Accessed on 8/6/2018] Avail-
 able from: https://libcom.org/tags/strategy-of-tension).

26. ECN.org. 2017. *Roma, Fiore: Servizi dietro Militia. Delle Chiaie
 regista dell'asse CasaPound-Lega* [online]. 13 December 2017
 [Accessed on 16/8/2018] Available from:http://www.ecn.
 org/antifa/article/5563/roma-fiore-servizi-dietro-militia-
 delle-chiaie-regista-dellasse-casapoun d-lega

27. A recent article in *Jacobin* outlines the tendency for the coun-
 try's political system to anticipate the rest of the world by a
 couple of decades: Broder, D. 2018 Italy is the Future, *Jacobin
 Magazine,* [online]. 4 March 2018. [Accessed on 8/6/2018]
 Available from: https://www.jacobinmag.com/2018/03/ital-
 ian-election-far-right-m5s-lega

28. Jones, S. 2018. Franco's cruel legacy: the film that wants to
 stop Spain forgetting, *The Guardian* [online]. 8/6/2018 [Ac-
 cessed 9/6/2018] Available from: https://www.theguardian.
 com/world/2018/jun/08/francos-cruel-legacy-film-wants-
 stop-spain-forgetting-silence-others

29. An account of how US counterculture post 1968 (on the west coast and Silicon Valley) embraced a conception of neoliberal ideology based on absolute faith in computational models deemed infallible *because* mathematical, and how such trust in machines would eliminate the conflicts arising from "classical" political activity is provided by Adam Curtis in some of his documentaries, especially in *All watched over by machines of loving grace* (CIRI, 2013. *All watched over by machines of loving grace – Episode 1 – Love and Power* [online] 3 December 2013 [Accessed on 4/8/2018] Available from: https://vimeo.com/groups/96331/videos/80799353).

30. La Vecchia, O., Mitchell, S. 2016. *Amazon's Stranglehold: How the Company's Tightening Grip Is Stifling Competition, Eroding Jobs, and Threatening Communities* [online]. November 2016 [Accessed on 4/8/2018] Available from: https://ilsr.org/wp-content/uploads/2016/11/ILSR_AmazonReport_final.pdf

31. The Future of Work, 2016. *Alles Flex?* [online]. 20 May 2016 [Accessed on 9/6/2018] Available from: https://vimeo.com/167414979

32. "To keep a mentally ill person costs approximately 4 marks a day. There are 300,000 mentally ill people in care. How much do these people cost to keep in total? How many marriage loans of 1000 marks could be granted with this money?" (NewFoundations, 2011. *The Educational Theory of Adolf Hitler* [online]. [Accessed on 8/6/2018] Available from: http://www.newfoundations.com/GALLERY/Hitler.html).

33. Reports show how people are being literally auctioned for ransom in Libya (Said-Moorhouse, L. 2017. Libya opens investigation into slave auction following CNN report. *CNN* [online]. 17 November 2017 [Accessed on 4/8/2018] Available from: https://edition.cnn.com/2017/11/17/africa/libya-slave-auction-investigation/index.html) and abandoned in the Sahara desert in Algeria (Anon. 2018. 13000 migrants abandoned in Sahara desert. *New York Post* [online]. 25 June

2018 [Accessed on 4/8/2018] Available from: https://nypost.
com/2018/06/25/13000-migrants-abandoned-in-sahara-de-
sert/).

34. Ross, A. R. 2017. *Against the Fascist Creep*, Chico, AK Press.

35. His name is often quoted as an inspiration for the new
course of the Lega Nord, which he praised for being "nor
left nor right" (Andriola, M. L. 2014. Alain de Benoist e
Matteo Salvini: una Lega Nord "al di là della destra e del-
la sinistra". *Paginauno* [online] n. 36, febbraio-marzo 2014
[Accessed on 9/6/2018] Available from: http://www.rivista-
paginauno.it/nuova-destra-lega-nord.php). In a recent in-
terview, he dismissed the Lega Nord for being a traditional
party, while praising the M5S for being the true populist
force in Italy (Cafasso, S. 2018. Populismo, de Benoist:
"questa Lega non è mia figlia". *Lettera43* [online]. 9 April
2018 [Accessed on 9/6/2018] Available from: http://www.
lettera43.it/it/articoli/politica/2018/04/09/de-benoist-lega-
m5s-nouvelle-droite-fondazione-feltrinelli/219 300/). In the
early days of the M5S, some commentators noted a number
of similarities between the movement's founding manifesto
and the first fascist manifesto, the aforementioned *Manifesto
di San Sepolcro* – above all, the pretence to surpass the "left-
right dichotomy". The first fascism, constituted by a varie-
gated ensemble of war veterans, with some young socialists
and anarchists, uneducated proletarians and conservative
middle-class people in its ranks, presented a much more
left-oriented set of points than those of the actual political
force that coagulated around the figure of Mussolini in the
1920s. As history showed, those left-wing elements of early
fascism were eliminated in the phase of structuring the dic-
tatorship. Similarly, the M5S, which owes its success to its
ability to intercept a wide spectrum of political positions
– even when those who hold them are convinced of their
being "apolitical"– relies on a significant base of declared

left-wing voters, who cannot find adequate representation in the "traditional left" (or that, at least, do not recognize themselves as adhering to an openly right-wing ideology). It is chilling to realize how, in recent months, the Lega Nord, which achieved 17 per cent in the March 2018 elections (its highest score ever, but recent polls already give it reaching a solid 31 per cent in its ascent to becoming the most popular party), has successfully "cannibalized" the M5S and its 35 per cent in government, imposing its extremely right-wing policies concerning migration, finance, health, labour and a worrying authoritarian approach to civil society and opposition. Now, Matteo Salvini is *de facto* the one who sets the policies of the whole government.

36. By this I do not mean that the society of the economic boom was immune from fascist tendencies and, as I will quote Pasolini later in the text, I have to point to his ever-present, fierce criticism of the consumerist society as one that, inherently fascist in its petty bourgeois, bigot morality, successfully updated fascism to its next phase. A phase in which there is no need of blackshirts and truncheons, as brainwashing would be performed by television and newspapers, the new *Ministry for Popular Culture*; and the police would take on the task of the *squadristi* in crushing any sort of organized resistance. A thorough analysis of Pasolini's correct as well as mistaken understanding of fascism in the post-war, consumerist Italian society was published online by the magazine *Internazionale*. (Wu Ming 1, 2018. Pasolini, Salvini e il neofascismo come merce, *Internazionale* [online]. 4 June 2018 [Accessed on 8/6/2018] Available from: https://www.internazionale.it/opinione/wu-ming-1/2018/06/04/pasolini-salvini-neofascismo).

37. Laclau, E., Mouffe, C. 1985. *Hegemony and the Socialist Strategy – Towards a Radical Democratic Politics*, Edition 2014. London: Verso Books.

38. Virgilio, M. 2015. *Futurismo e politica: Le origini, il confronto con Mussolini, lo scontro con Hitler.* [Kindle].

39. Ross, A. R. 2017. *Against the Fascist Creep*, Chico, AK Press. Another clue that history does not proceed in a straight line towards progress is the resurfacing of *red-brown* arguments in later years, a phenomenon in which quotations by Marx and other left-wing figures are used in an extravagant and partial way to justify extreme-right policies on immigration and protectionism. One of the leading figures of this field in Italy is the self-appointed Marxist philosopher Diego Fusaro, published by mainstream publishers, *abitué* of political talk shows and friend of CasaPound. Mauro Vanetti dedicated a long post – soon also available in English – to the debunking of myths such as the "immigration as a reserve industrial army that lowers the salaries" by the rigorous analysis of Marx's own words. (Vanetti, M. 2018. Lotta di classe, mormorò lo spettro, *Giap!* [online]. 25/6/2018 [Accessed 14/8/2018] Available from https://www.wumingfoundation.com/giap/2018/06/marx-immigrazione-puntata-1/). But this is true not only for Italy: Angela Nagle, author of a much circulated book about the alt-right and generally (perhaps too quickly?) perceived as a left-wing figure, recently published an article titled "The Left Case against Open Borders" with the exact same argument: a mix of confused statements, in which labour and capital are basically the same, migrants are depicted as merely puppets of big capital and "the left" becomes a bunch of boogie, white, hysteric avocado lovers, happy to be served soya cappuccinos by "Ethiopian PhDs". Uncritically repeating such baseless claims as a broken record only assists trumpist arguments, *de facto* legitimizing their positions "from the left". (Nagle, A. 2018. The Left Case against Open Borders, *American Affairs*, Volume II, Number 4 (Winter 2018): 17–30. [online]. [Accessed on 29/11/2018] Available from: https://

americanaffairsjournal.org/2018/11/the-left-case-against-open-borders/)

40. Virgilio, M. 2015. *Futurismo e politica: Le origini, il confronto con Mussolini, lo scontro con Hitler.* [Kindle].

41. Ialongo, E. 2015 *Filippo Tommaso Marinetti: The Artist and His Politics (The Fairleigh Dickinson University Press Series in Italian Studies),* Fairleigh Dickinson University Press.

42. Noys, B. 2014 *Malign Velocities – Accelerationism and Capitalism,* Winchester: Zero Books.

43. "We intend to glorify war – the only hygiene of the world – militarism, patriotism, the destructive gesture of anarchists, beautiful ideas worth dying for, and contempt for woman". Marinetti, F. 1909, Manifesto del Futurismo, *Le Figaro* 20/2/1909 [Accessed on 8/6/2018] Available from: https://www.unknown.nu/futurism/manifesto.html

44. Echoes of the elimination of the human and the embracing of the machine can be found in other episodes of accelerationism throughout the last century, such as the cyberpunk movement of the 1990s, or Silicon Valley's artificial intelligence dreams.

45. Zapperi, G. 2018, *Myth versus history: some notes on Italian Futurism.* 17 March 2018, BAK Utrecht.

46. Marinetti, F. 1909, Manifesto del Futurismo, *Le Figaro* 20/2/1909 [Accessed on 8/6/2018] Available from: https://www.unknown.nu/futurism/manifesto.html

47. Ibid.

48. Here one could open a whole new line of analysis concerning the correlation between fascist *machismo*, the *alpha male* phenomenon, and the ostentation of the masculine as a reaction to the fear of falling for the *queer*. (ContraPoints. 2016. *Alpha Males* [online]. [Accessed 8/6/2018]. Available from: https://www.youtube.com/watch?v=k6jYB74UQmI). An excellent source for deepening the subject of patriarchy and misogyny in the context of the establishment of fas-

cism, and its intense hatred of all that was deemed impure, is Klaus Theweleit's *Male Fantasies* (Theweleit, K. 1987. *Male Fantasies – Women, Floods, Bodies, History.* University of Minnesota Press). To expand this topic with a more contemporary example, one could think to the recent years' surge, in the porn industry, of the so-called "interracial porn", in which black actors have intercourses with white actresses, often while the woman's white husband is watching. As explained by a recent article in *Vice* magazine, in 2017 the industry has touched its all-time high, and its ascent seems nowhere near to stopping. This sub-genre of an already problematic industry represents the depiction of the ultimate undermining of white men's patriarchal power, and a cathartic projection of his deepest fears. The recent increase in consumption of such products, especially by US white men, the author argues, goes hand in hand with the violent resurfacing of issues of white supremacy since the Trump election, and a powerful re-activation of the nightmare of the colonizer: the colonized subject, the black man, comes back and bites the colonizer in its most intimate and valuable asset: his patriarchal control over the woman's body. (Samudzi, Z. 2018, What "Interracial" Cuckold Porn Reveals About White Male Insecurity, *Broadly*, [online]. 31 July 2018 [Accessed 12/8/2018] Available from: https://broadly.vice.com/en_us/article/594yxd/interracial-cuckold-porn-white-male-insecurity-race).

49. Eco, U. 1995, Ur–Fascism, *The New York Review of Books*, [online]. Volume 42, Number 11 [Accessed 8/6/2018] Available from: https://www.nybooks.com/articles/1995/06/22/ur-fascism/. I would add here one of the most famous quotes from Mussolini's early days as a member of parliament: "Fascism is anti-socialist, and that's it!"

50. A thorough account of the birth of CPI can be found in a recent *Long Read* article by the Guardian (Jones, T. 2018.

The fascist movement that has brought Mussolini back to the mainstream, *The Guardian* [online]. 22 February 2018 [Accessed on 8/6/2018] Available from: https://www.theguardian.com/news/2018/feb/22/casapound-italy-mussolini-fascism-mainstream). The article also serves as a good example of the trap which I like to call *The Discreet Charm of Neo-Fascism*, in which the author seems to fall, to a certain degree, for the romantic account of the founders, portraying them as a group of restless punk-rock youth in their late 20s that happen to unimpededly squat a 5000m$_2$ building (belonging to the Ministry of Public Education and worth some 11 million euros – the amount of money that the Municipality of Rome, then led by the neo-fascist politician Gianni Alemanno, paid for its purchase in 2009 to ensure the permanence of CPI in its premises) in one of the most lucrative neighbourhoods of the centre of Rome, just in order to hold rehearsals for their neo-Nazi rock band. More examples of such soft treatment will follow later in the text.

51. Hence the self-definition of *"non-conformist occupations"* with which the militants try to position themselves one step further on the scale of antagonism than the "conformist" occupations, i.e. the hundreds of left-wing and anarchist occupations that since the early 1970s emerged from the galaxy of extra-parliamentary left militancy.

52. In an article from 2004, the left-leaning newspaper *La Repubblica* describes it as a "right-wing social centre" in which activists and citizens dedicate their free time to social and community projects in a "non-conformist" way, providing housing for disadvantaged Italians and stray dogs. (Occhipinti, M. 2004. Il centro sociale? Anche di Destra – Ecco le Occupazioni Non Conformi, La Repubblica [online]. 25 January 2004 [Accessed on 8/6/2018] Available from: http://ricerca.repubblica.it/repubblica/archivio/repubblica/2004/01/25/il-centro-sociale-anche-di-destra-ecco.rm_0

33il.html).

53. Some more examples of *TDCONF* on the media: here, Daniel Swift from *Lithub* sells himself for a free dish of spaghetti at a CPI owned restaurant (Swift, D. 2017, Hanging out with the Italian neo-fascists who idolize Ezra pound, *Literary Hub* [online]. 7 November 2017 [Accessed on 8/6/2018] Available from: https://lithub.com/hanging-out-with-the-italian-neo-fascists-who-idolize-ezra-pound/); here, the Italian women's magazine *MarieClaire* makes sure we don't fall under the impression that women, in fascist milieus, are deemed as inferior subjects and asks: just who are the women of CasaPound? (Burchiellaro, D. 2017. Che cosa sai veramente delle donne di Casapound? *MarieClaire* [online]. 3 November 2017 [Accessed on 8/6/2018] Available from: www.marieclaire.it/Attualita/news-appuntamenti/chi-sono-le-donne-di-casaPound); here the magazine *L'Espresso* welcomes us to CasaPound with 45 black and white photographs, by photographer Alessandro Cosmelli, depicting some glamorous moments of *the merry life as a neo-fascist* (Di Feo, G. 2009. Benvenuti a CasaPound, *L'Espresso* [online]. 22 May 2009 [Accessed on 8/6/2018] Available from: http://espresso.repubblica.it/foto/2009/05/22/galleria/benvenuti-br-a-casa-pound-1.62487#1); here, again *L'Espresso* grants 23 questions to CPI's leader Gianluca Iannone to let him explain his worldview in the occasion of their run for Rome's 2012 elections, and leaves unchallenged his argument clearing CPI of any complicity in the murder of two Senegalese street vendors by one of their activists in 2011 (Capriccioli, A. 2012. Roma, CasaPound spiazza tutti, *L'Espresso* [online]. 8 February 2012 [Accessed on 8/6/2018] Available from: http://espresso.repubblica.it/palazzo/2012/02/08/news/roma-casapound-spiazza-tutti-1.40175); And this list could go on and on.

54. So much for the "fascism of the second millennium". Oh no,

wait, what? CasaPound's candidate wants to annex western Libya? (Anon, Italian Presidential Candidate Wants Annexation of Western Libya, *The Libya Times* [online]. 20 January 2018 [Accessed on 8/6/2018] Available from: http://www.libyatimes.net/news/98-italian-presidential-candidate-wants-annexation-of-western-libya).

55. It consists of a sort of *pogo*, as in punk-rock music, but the shirtless participants take off their belts and violently wave them around, while jumping, as whips, in order to hit and be hit with the buckles. If you like to see fascists beating each other, here's a video (Zetazeroalfa. 2007. Cinghiamattanza – Official Video [online]. [Accessed on 8/6/2018] Available from: https://www.youtube.com/watch?v=drsUhWuyA9I). This male-only ritual, which exudes bravado, masculinity and defiance of fear, is intended to embolden the spirit and heighten the tolerance to pain, in an accurately painful rehearsal of a street fight. Indeed belts, next to knives, are one of fascists' favourite weapons in their nightly expeditions which, despite the rhetoric which they like to use to ennoble their endeavours, are not to be confused with "futurist" happenings.

56. Pivert. 2018. [online]. [Accessed on 12/8/2018] Available from: https://www.pivert-store.com/about-us-2?lang=en

57. Ibid.

58. As very well explained by Selene Pascarella in a long post on *Giap!* titled "The F-word", the Italian media has encountered huge difficulties in calling things by their names. It is not only an Italian tendency, as worldwide acts of terrorism and racist violence perpetrated by white men are generally framed as motivated by insanity or obscure reasons, and are always depoliticized as soon as the news spreads. (Pascarella, S. 2017. Il Format con la F. L'omicidio #Alatri e la violenza fascista che i media preferiscono ignorare, *Giap!* [online] 24 April 2017 [Accessed on 8/6/2018] Available

from: https://www.wumingfoundation.com/giap/2017/04/omicidio-di-alatri-e-parola-con-la-f/).

59. At the beginning of 2017, Germany decided not to award any official recognition to the Italian policemen who killed the suspected terrorist of the "Christmas market attack" of 19 December 2016 in Berlin, after a number of posts praising fascism were found on their Facebook profiles. Italian authorities were not of the same opinion. (Olterman, P., Kirchgaessner, S., and Tondo, L., 2017. Police who killed Berlin attacker made pro-fascist statements online, *The Guardian* [online]. 15 February 2017 [Accessed on 8/6/2018] Available from: https://www.theguardian.com/world/2017/feb/15/italian-police-killed-berlin-attacker-pro-fascist-statements-online).

60. Similarly, in the US all kinds of white supremacists and racist terrorists recognize themselves under the Confederate flag, and are subject to the "lone wolf" treatment; their evidently racist motivation appears to be invisible to most commentators.

61. The region of Macerata, in central Italy, is at the crossroads of the major heroin routes from central Asia via the Balkans and North Africa, and suffers particularly the problem of drug addiction. One well known fact, among Italian grassroots left-wing movements, is the connection that fascist organizations always had with heroin trafficking in order to finance their activities. In 1980 the Autonomia Operaia militant Valerio Verbano, 18-years-old, was killed in the house where he lived with his parents in Rome, due to an investigation that he was successfully carrying out on this subject. The notebook containing his findings was stolen by his killers. Every year, on 22 February, a large demonstration in his memory takes place in the neighbourhood (Wikipedia. 2007. *Valerio Verbano* [online]. [Accessed on 8/6/2018] Available from: https://it.wikipedia.org/wiki/Valerio_Verbano).

62. Many noted the alarming correlation of such events with the incendiary rhetoric used by Lega Nord's leader Matteo Salvini (Italy's new Minister of Interior) who on several occasions openly called for an "ethnic cleansing" of Italy (Last Week Tonight. 2018. *Italian Election: Last Week Tonight: John Oliver (HBO)* [Accessed on 8/6/2018] Available from: https://www.youtube.com/watch?v=LdhQzXHYLZ4&feature=youtu.be&t=8m5s). Traini has been a candidate for Salvini's party in a recent administrative election round, receiving no votes. In the period between the inauguration of the new government, on 1 June, and the beginning of August, more than 40 attacks against immigrants and Roma people, at almost daily frequency (to which many other reports of verbal assaults can be added), carried by guns and other less lethal weapons, have made the news. In some cases, people shot with air guns or live ammo from windows and balconies (one claimed he was "cleaning the rifle", another that he was "aiming at a pigeon"). In another case, a young black Italian national athlete was hit in the face by an egg thrown at her from a car while she was walking home at night. After a few days, the police found that the authors of the aggression were a bunch of teenagers allegedly targeting Nigerian prostitutes for fun. The police decided to drop the racial hatred, because the gesture was "not motivated by racism". On the contrary, many voices from the right accused the left of being racist themselves, for pointing out that the attack was carried out against a black woman: "the skin colour is not a factor in the prank, they didn't even notice that she's black". It is painful to acknowledge how, in 2018, Italy is a society that does not understand how three white, Italian bourgeois kids, driving around in dad's car at night targeting black enslaved women, is an illustration of a systemic white supremacy that is not even able to acknowledge its own existence. A map has been made

by journalist Luigi Mastrodonato to keep track of these attacks. (Mastrodonato, L. 2018. Aggressioni razziste dall'1 giugno 2018 – Insediamento nuovo governo [online] [Accessed on 16/8/2018] Available from: https://www.google.com/maps/d/viewer?mid=1kjmhct5NVKjSwAfo9Ondqprh-gQ6OEr8A&ll=45.56635623068137%2C9.849484062499982&z=5).

63. Because of a – at least – decade's long overrepresentation of the migratory phenomenon and its problems in the media, Italians believe that one in four persons living in the country is an immigrant, the real number being a scarce 8 per cent. This is by far the highest discrepancy in the EU. (Harris, C. 2018. How many migrants in your country? Probably fewer than you think. *Euronews* [online] 17 April 2018 [Accessed on 6/9/2018] Available from: http://www.euronews.com/2018/04/17/italians-and-much-of-the-eu-heavily-over-estimate-immigrant-numbers).

64. It is one of the most important recurrences for the Italian extreme right, commonly referred to as the Massacre of Acca Larentia (Wikipedia. 2011. *Acca Larentia killings* [online]. [Accessed on 8/6/2018] Available from: https://en.wikipedia.org/wiki/Acca_Larentia_killings).

65. Jesi, F. 1979. *Cultura di Destra*, Milano: Aldo Garzanti Editore.

66. My translation. A conversation on this often-overlooked scholar (sometimes labelled as a sort of "Italian Benjamin" because of the overlappings between their respective fields of research, especially regarding myth and theatre, and his early death which left a great deal of unfinished work) and several other resources can be found on Giap! (Wu Ming, 2013. Il più odiato dai fascisti. Conversazione su Furio Jesi, il mito, la destra e la sinistra, *Giap!* [online]. 15 January 2013 [Accessed on 8/6/2018] Available from: https://www.wumingfoundation.com/giap/2013/01/il-piu-odiato-dai-fascisti-

conversazione-su-furio-jesi/).

67. The Hobbit Camps were held for 4 years, since 1977 to 1981 (with the exception of 1979). Named after the *Lord of the Rings* characters, they intended to put in place an operation of culturalization of right-wing ideology, proposing it as an alternative force to both capitalism and communism. In those camps, the obsession of the right wing for Tolkien (whose oeuvre's message was wildly distorted and bent to the necessity of instituting a basic cultural reference for the New Right) manifested to a grotesque level. For an extensive critique of Tolkien as a writer that embodies all the foundational aspects of the right wing, see the work of Wu Ming 4 (Wu Ming 4, 2010-2018. Archives for JRR Tolkien, *Giap!* [online]. [Accessed on 8/6/2018] Available from: https://www.wumingfoundation.com/giap/tag/jrr-tolkien/).

68. Last, J. 2017. How "Hobbit Camps" rebirthed Italian Fascism, *Atlas Obscura* [online]. 3 October 2017 [Accessed on 8/6/2018] Available from: https://www.atlasobscura.com/articles/hobbit-camps-fascism-italy

69. Just to name three of the most important ones: "Operation Gladio" (hejjagheterpal, 2012. *Operation Gladio – Full 1992 documentary BBC* [online] 7 July 2012 [Accessed on 13/6/2018] Available from: https://www.youtube.com/watch?v=GGHXjO8wHsA), the "Golpe Borghese" (Wikipedia, 2005. *Golpe Borghese* [online]. [Accessed on 13/6/2018] Available from: https://en.wikipedia.org/wiki/Golpe_Borghese), and the "Propaganda Due" Masonic lodge (Wikipedia, 2002. *Propaganda Due* [online]. [Accessed on 13/6/2018] Available from: https://en.wikipedia.org/wiki/Propaganda_Due).

70. Founded in 1997 by Roberto Fiore (then fugitive in London), Forza Nuova presents itself with a much less mainstream set of beliefs (Christian fundamentalism, anti-Semitism, holocaust denial, homophobia) than CPI, and has a much

smaller base of militants as well. What's interesting is that the comparison between the two groups (and the general condemnation that hits FN) is one of the factors that allows CPI to enjoy the status of a "clean and vital" movement. This definition was given by anchorman Corrado Formigli after his participation in a public "debate" organized in CPI's headquarters in Rome which raised a lot of controversy at the end of 2017 (Anon, 2017. Corrado Formigli elogia CasaPound: "Un movimento vitale e pulito", *Giornalettismo* [online] 5 October 2017 [Accessed on 8/6/2018] Available from: https://www.giornalettismo.com/archives/2634456/corrado-formigli-casapound). For those interested, a lengthy description of FN can be found on their US website –yes, they have one (Forza Nuova USA 2018. [online]. [Accessed on 8/6/2018] Available from: http://www.usa.forzanuova.info/what-is-forza-nuova/).

71. This sentence comes directly from Pasolini, who in a famous interview seems to warn about the "fascism of the antifascists". This is often misquoted by the right wing to attack antifascists whenever attempts are made to contrast public events of the far right, picturing the leftists as antidemocratic: "See? Even Pasolini says you're wrong. These categories are antiquated, there's no need to bark against something that doesn't exist anymore, you are just a tool of the system. And, by the way, he loved the police". A lot has been written about this, and by quoting a single sentence in order to make my point I am performing the same trick used to distort his thought, but his words here are directed towards the parties in power (at the time, a mere 3 years after the end of the war, still strongly bound to antifascism as a foundational element) which "will continue to organize other murders and slaughters, and therefore to invent fascist hitmen; as to create an antifascist tension in order to craft for themselves an antifascist virginity...but, at the

same time, *maintaining the impunity of the fascist gangs that, if only they would like to, they could vanquish in a day"*. About the conflictual and firmly antagonistic position of Pasolini towards the establishment and the police, and the instrumental, deliberate distortion of his words by the right wing, read "The Police vs. Pasolini, Pasolini vs. the Police" (Wu Ming 1, 2016. *The Police vs. Pasolini, Pasolini vs. the Police* [online]. [Accessed on 8/6/2018] Available from: https://www.versobooks.com/blogs/2719-the-police-vs-pasolini-pasolini-vs-the-police).

72. Malkin, B. 2018. SpaceX Oddity: how Elon Musk sent a car towards Mars, *The Guardian* [online] 7 February 2018 [Accessed 8/6/2018] Available from: https://www.theguardian.com/science/2018/feb/07/space-oddity-elon-musk-spacex-car-mars-falcon-heavy. The car carries a puppet astronaut (nicknamed *Starman*) chilling with his arm out on the driver's seat, it blasts David Bowie's *Life on Mars* from its speakers (even though *in space nobody can hear you scream*), and features the famous cover quote from the *Hitchhiker's Guide to the Galaxy* "Don't Panic!" on its display. If everything goes well, it might orbit around Mars for, potentially, millions of years. Funnily enough, it took less time to ship one such car into orbit than to deliver the other ones to the garages of those who ordered their Teslas in 2016.

73. "D'Annunzio's personal motto 'per non dormire' ('In order not to sleep') captures perfectly, in advance, this vectoring of the human will into a mechanized acceleration that displaces any organic need. It might also stand as the motto for contemporary capitalism, which, as Jonathan Crary has noted, declares war on sleep as one of the few residual and non-productive human activities". Noys, B. 2014 *Malign Velocities – Accelerationism and Capitalism*, Winchester: Zero Books.

74. His giant villa, the famous Vittoriale D'Italia (Shrine of Ital-

ian Victories, where he collected an impressive amount of artwork, objects and other memorabilia including an airplane and a warship) on the Garda Lake, is a popular site visited by thousands of people every year. (King, C. 2013. D'Annunzio and Il Vittoriale Degli Italiani: A Poet's Fantasy. italy magazine, [online] 15 April 2013 [Accessed on 16/8/2018] Available from: http://www.italymagazine.com/featured-story/dannunzio-and-il-vittoriale-degli-italiani-poets-fantasy).

75. Esposito, F. *Fascism, Aviation and Mythical Modernity.* 2015. London: Palgrave Macmillan.

76. "Just in case *something* goes wrong with Earth" (Inverse. 2016. *Elon Musk talks about the need to colonise Mars* [online]. [Accessed 8/6/2018] Available from: https://www.youtube.com/watch?v=3gTnBXoiHWc).

77. Like selling a flamethrower for $500 in the country leading by far all murder statistics. (Etherington, D. 2018. Elon Musk's Boring Co. flamethrower is real, $500 and up for pre-order, *Techcrunch* [online] 28 January 2018 [Accessed on 8/6/2018] Available from: https://techcrunch.com/2018/01/27/elon-musks-boring-co-flamethrower-is-real-500-and-up-for-pre-order/?guccou nter=1).

78. "I'm old enough to remember when it was the astronauts and scientists who got credit for space exploration, not the parasitic CEOs who profit from their work". @existential-comics (Existential Comics, 2018. [online] 13 June 2018 [Accessed on 13/6/2018] Available from: https://twitter.com/existentialcoms/status/1006702365280354304).

79. The Golden Record is the name of two phonograph records placed on board the spacecraft Voyager 1 and Voyager 2 before their launch in 1977, intended to carry the witness of Earth's life forms into outer space, potentially to be intercepted by extraterrestrial forms of intelligent life (NASA. *The Golden Record.* [online] [Accessed on 30/9/2018] Avail-

able from: https://voyager.jpl.nasa.gov/golden-record/).

80. Benjamin, W. 2008. *The Work of Art in the Age of Mechanical Reproduction*. London: Penguin Books.

81. Friedland, P. *Political Actors. Representative Bodies and Theatricality in the Age of the French Revolution*. 2002. Ithaca, United States: Cornell University Press.

82. "The tradition of all dead generations weighs like a nightmare on the brains of the living. And just as they seem to be occupied with revolutionizing themselves and things, creating something that did not exist before, precisely in such epochs of revolutionary crisis they anxiously conjure up the spirits of the past to their service, borrowing from them names, battle slogans and costumes in order to present this new scene in world history in time-honored disguise and borrowed language. Thus Luther put on the mask of the Apostle Paul, the revolution of 1789-1814 draped itself alternately in the guise of the Roman Republic and the Roman Empire, and the revolution of 1848 knew nothing better to do than to parody, now 1789, now the revolutionary tradition of 1793-95. In like manner, the beginner who has learned a new language always translates it back into his mother tongue, but he assimilates the spirit of the new language and expresses himself freely in it only when he moves in it without recalling the old and when he forgets his native tongue." (Marx, K. 1852. *The 18th of Brumaire of Napoleon Bonaparte* [online]. [Accessed on 9/6/2018] Available from: https://www.marxists.org/archive/marx/works/1852/18th-brumaire/ch01.htm).

83. Citizens who, by burning down this or that palace every once in a while – bless the Faubourg Saint-Antoine! – reminded the various political factions of the reason why they were there in the first place, and that their heads were less firmly attached to their necks than they liked to think.

84. The French Revolution is one of the most minutiously

documented events of all time. The Blibliothèque National de France keeps an extensive archive of all parliamentary acts and minutes of every single day, including a vast collection of popular visual items, illustrations, medals, coins and other objects, which display aspects of the Revolution. (Stanford University Libraries. 2018. *French Revolution Digital Archive*. [Online]. [Accessed on 22 September 2018]. Available from: https://frda.stanford.edu/).

85. Groys, B. *In the Flow*. 2016. London: Verso Books.

86. Again, nothing new if one thinks of the repeated claims, by Berlusconi and his acolytes, that "the communists have ruled Italy for 50 years" and of the need to be done with the "culture of '68".

87. Be sure, with this I do not want to reproduce the "migrants are the reservoir army that capitalism uses to lower the wages in the West" red-brown argument.

88. Steyerl, H. 2017. *Duty Free Art*, London: Verso Books.

89. "Freeport art storage is to this "stack" as the national museum traditionally was to the nation. It sits in between countries in pockets of superimposing sovereignties where national jurisdiction has either voluntarily retreated or been demolished. If biennials, art fairs, 3-D renderings of gentrified real estate, starchitect museums decorating various regimes, etc., are the corporate surfaces of these areas, the secret museums are their dark web, their Silk Road into which things disappear, as into an abyss of withdrawal". Ibid.

90. The Louvre museum, for example, doesn't scorn the millions of euros coming in yearly via its newly built Abu Dhabi branch, whose construction has been reportedly carried, as is common practice in the UAE, by workers in conditions of semi-slavery. Besides France's most important museum, the Guggenheim and New York University also directed their attention to possible revenues coming from the emirate. (Batty, D. 2013. Conditions for Abu Dhabi's

migrant workers "shame the west". *The Guardian* [online] 22/12/2013 [Accessed on 5/10/2018] Available from: https://www.theguardian.com/world/2013/dec/22/abu-dhabi-migrant-workers-conditions-shame-west).

91. Vishmidt, M. [Forthcoming] Anti-fascist Art Theory: On the Potential of Critique. *Third Text.* Roundtable with Dimitrakaki, A. and Gogarty, L.A.

92. In 2016, a video by artist Simon Denny, one of the main figures of the crypto-enthusiast bitcrowd, described the vision of the world that the blockchain would implement (Denny, S. 2016. Blockchain Future States. *E-flux.* [online] 17 January 2017 [Accessed on 28/9/2018] Available from: https://www.e-flux.com/architecture/superhumanity/68703/blockchain-future-states). The vision here described resembles very much the one of a video published, in 2008, by the Casaleggio Associati, the marketing agency led by Gianroberto Casaleggio (the founding father of the 5 Star Movement, together with TV comedian Beppe Grillo) that crafted the cultural and material infrastructure of the "movement". To be fair, Simon Denny's video does not have the same conspiracy theory tone and rhetoric, but at the base of both discourses is the idolization of networks, the dogmatic trust in technology as a subject and not a means, and the ultimate desire for the dissolution of politics into technocracy (Casaleggio Associati. 2008. *Gaia. The future of politics.* [online]. [Accessed on 28/9/2018] Available from: https://www.youtube.com/watch?v=sV8MwBXmewU).

93. Or like Unity from Rick and Morty's episode "Auto Erotic Assimilation", a former date of Rick's , whose peculiarity is being an alien entity that thrives by possessing and using external bodies to her own goal, that of "assimilating" the whole universe and becoming "what the single-minded once called a god". Her power is so strong that she is able to control an entire planet, turning it into a perfectly efficient

world in which everybody is deprived of their freedom and consciousness, with the gain of living in perfect harmony. (Adult Swim. 2017. *Rick and Morty: Auto Erotic Assimilation* [online] Available from: http://www.adultswim.com/).

94. "The Art Right" exposes London gallery LD50 and its support for alt-right, as well as the development of a right-wing esthetic aimed at recruiting new members. (Gogarty, L. A. 2017. The Art Right, *Art Monthly*, 17 April. [Accessed on 8/6/2018] Available from: https://archive.ica.art/sites/default/files/downloads/The%20Art%20Right%20-%20Art%20Monthly%20April%2020 17.PDF).

95. Ibid.

96. Contemporary art seems to be, for example (both consciously and unconsciously), facilitating global processes of gentrification. The REALTY study group of the Dutch Art Institute carried out thorough research from the perspective of an experimental educational programme in the arts, which was condensed in a script and performed in Athens in June 2018. (omnifagos, 2018. REALTY. [online] [Accessed on 1/19/2018] Available from: https://vimeo.com/276244498).

97. Gogarty, L. A. 2017. The Art Right, *Art Monthly*, 17 April. [Accessed on 8/6/2018] Available from: https://archive.ica.art/sites/default/files/downloads/The%20Art%20Right%20-%20Art%20Monthly%20April%2020 17.PDF.

98. Turner wrote an open letter accessible on his website, describing in detail the scope of the abuses he has been subject to, and linking the responses of the Biennale. (Turner, L. 2018 *An open letter to the participating artists and sponsors of the 2018 Athens Biennale.* [Accessed on 7/10/2018] Available from: http://luketurner.com/athens-biennale-2018-withdrawal/). Shut Down LD50, the network of artists that formed in opposition to the 2016 conferences in London, wrote a letter of solidarity to Turner, renaming the Athens Biennale as "The Biennale of Very Fine People,

on Both Sides" and stating that "The Biennial's vision of 'ANTI' (the name of this year's Biennial) as an 'attitude', as non-conformity detached from any definite political orientation, and of 'marginality' abstracted from social history, is presented as a daring transgression of rigidified political correctness. It is in fact a badly written celebration of the 'pleasure' of political centrism...They say that 'ANTI is not a neutral discussion platform but an agonistic space hosting different approaches on how to deal with ominous tendencies in politics and culture. Diverse voices are essential to initiate a meaningful discussion on how to combat such issues. Dealing with these controversial issues is the exact core of the conceptual framework of the exhibition and denotes the urgency of ANTI'. But all that this amounts to is yet another confirmation of the disabling self-regard of the bourgeois arts professional for whom nothing is more urgent, or more terrifyingly under threat, than the 'diverse', 'meaningful', 'controversial', and 'agonistic' sound of their own voice, along with all of the vulnerable adjectives that they are paid by the word to say in it." (SDLD50, 2018. *The Biennale of Very Fine People, on Both Sides* [Accessed on 7/10/2018] Available from: https://shutdownld50.tumblr. com/post/177951753921/the-biennial-of-very-fine-people-on-both-sides).

99. The fascist regime seems to have foreseen the future relevance of Gramsci's thought, if it's true that during the trial, his prosecutor said: "For 20 years we must prevent this brain from functioning." The good news is that they didn't succeed (Hoare, Q. and Smith, G. N. 1971. *Selections from the Prison Notebooks*. New York: International Publishers).

100. Toscano, A. 2017. Notes on Late Fascism, *Historical Materialism* [online]. 2 April 2017 [Accessed 8/6/2018] Available from: http://www.historicalmaterialism.org/blog/notes-late-fascism

101. Steyerl, H. 2017. *Duty Free Art*, London: Verso Books.

102. For example, the badges and fancy uniforms that were spotted in winter 2018 at the border between the Italian and French Alps. In this case, a handful of neo-fascists sporting fashionable, electric blue puffer jackets, "sealed" the border with a 100m-long plastic fence and left after a few hours, in a purely demonstrative gesture, highly publicized and well-orchestrated, which included a helicopter with their logo taking aerial footage. A *representation* of the thing, rather than the thing *itself*. (Anon. 2018. Right-wing group seeks to stop migrants crossing French Alps, *Infomigrants* [online] 24 February 2018 [Accessed on 8/6/2018] Available from: http://www.infomigrants.net/en/post/8834/right-wing-group-seeks-to-block-migrants-crossing-french-alps).

103. Gramsci defines the figure of the *intellectual organic to the working class*. What he refers to is the Party, which has to be the collective mind, composed by militants, workers and intellectuals educating the masses and directing them towards the communist society. If, as it seems, the party is gone, what should the role of the intellectuals be in the twenty-first century?

104. Mouffe, C. 2018. Jeremy Corbyn's Left Populism, *Verso Blog* [online] 16 April 2018 [Accessed on 8/6/2018] Available from: https://www.versobooks.com/blogs/3743-jeremy-corbyn-s-left-populism; Mouffe, C., Eribon, D. 2017, Populism. A Dialogue on Art, Representation and Institutions in the Crisis of Democracy, *L'Internationale Online* [online] 8 June 2017 [Accessed on 8/6/2018] Available from: http://www.internationaleonline.org/dialogues/14_populism_a_dialogue_on_art_representation_and_institutions_i n_the_crisis_of_democracy.

105. Jesi, F. 1979. *Cultura di Destra*, Milano: Aldo Garzanti Editore.

106. This would be another example of the *red-brown* arguments

discussed in note 39.

107. With a bit of a generalization: when the left, in the wake of the striking electoral successes of Thatcher and Reagan, started trying to capture voters by promising what they wanted – rather than convincing them of the necessity to understand the world and change themselves – it signed its own dissolution, and became responsible for the loss of the intellectual tools of a whole ruling class. The first electoral gains, crafted by spin doctors borrowed from marketing, prepared the stage for the seemingly unstoppable rise of the right. The fact that this rise is imbued of a collectivist rhetoric that appeals to unity and to the *nation*, while the left keeps chasing an improved version of individualism (at best dressed by pro-EU rhetoric, hence only just slightly moving the border of the national body) should give food for thought.

108. Dean, J. 2012. *The Communist Horizon*, London: Verso Books.

109. This issue is particularly resonant when juxtaposed with the experience of certain factions of the No Global movement of the late 1990s, especially the ones evolving from the late instances of the Autonomia Operaia. Inspired by Negri and Hardt's theory of the imminent dissolution of capitalism, movements such as the Tute Bianche adopted a strategy of creative representation of the "assault on the winter palace" made of masquerades, mockery of the power and riots staged in previous accordance with the police. Confronted with unexpected, *actual* state repression on the streets of Genoa in July 2001, this strategy revealed its dramatic outcome with the death of Carlo Giuliani, and opened a crisis from which European movements only managed to partially emerge a decade later, with the Indignados movement. Another good example of a post-situationist practice that was very influential in those years, especially in Italy, is the *Luther Blissett Project*, the prankster international that

reunited hundreds of artists and other cultural workers in order to "raise hell in the cultural industry" by means of hoaxes played on the press and a vast range of *psychic warfare* tactics. (Luther Blissett, 1994. [online]. [Accessed on 30/9/2018] Available from: http://lutherblissett.net/).

110. KOW. 2018. *Was euch am Leben hält, ist, was bei uns zu Asche zerfällt.* [online] 7 September 2018 [accessed on 16/9/2018] Available from: https://www.kow-berlin.com/exhibitions/das-was-euch-am-leben-halt-ist-das-was-bei-uns-zu-asche-zerfiel

111. Ibid.

112. Stuchbery, M. 2018. *A Day for Fear* [online]. 7 May 2018 [Accessed on 8/6/2018] Available from: http://mike-stuchbery.org/index.php/2018/05/07/a-day-for-fear/

113. Again, Natalie Wynn (ContraPoints) offers a witty and compelling overview of the issue. ContraPoints. 2017. *Does the Left Hate Free Speech? (Part 1)* [online]. [Accessed on 4/10/2018] Available from: https://www.youtube.com/watch?v=GGTDhutW_us

114. Anon. 2018. Ai Weiwei defends Selfie with Far-Right AfD Leader, *Frieze* [online] 23 April 2018 [Accessed on 8/6/2018] Available from: https://frieze.com/article/ai-weiwei-defends-selfie-far-right-afd-leader

115. For example, one could notice how the supposedly apolitical, highly hedonistic aspects of some subcultures of the 1980s (such as the Italian *paninari,* who emerged after 2 previous decades of diffuse class struggle, and in open opposition to radicalized left-wing youth) echo the fashions of the post-Thermidor phase of the French Revolution, with its *muscadins,* or *golden youth,* children of the revived aristocracy, whose favourite activity was the harassment of revolutionaries and proletarians. Their excessive, self-ironic and extravagant fashion was a proud statement of their membership in the aristocracy, and would nowadays surely find

appreciation in some areas of the alt-right, or among the hipster fascists. (Wikipedia, 2006. *Muscadin* [online]. [Accessed on 9/6/2018] Available from: https://en.wikipedia.org/wiki/Muscadin).

116. Clarke, H. 2018. Italy's Salvini channels Mussolini in tweet on late dictator's birthday. *CNN* [online] 30 July 2018 [Accessed on 16/8/2018] Available from: https://edition.cnn.com/2018/07/30/europe/salvini-mussolini-italy-intl/index.html

117. Nafisi, G. 2018 *Conversation with the author.* 5 July.

Bibliography

Adult Swim. 2017. *Rick and Morty: Auto Erotic Assimilation* [online] Available from: https://www.adultswim.com/

Andriola, M. L. 2014. Alain de Benoist e Matteo Salvini: una Lega Nord "al di là della destra e della sinistra". *Paginauno* [online] n. 36, febbraio-marzo 2014 [Accessed on 9/6/2018] Available from: http://www.rivistapaginauno.it/nuova-destra-lega-nord.php

Anon, 2012. Italy memorial to fascist hero Graziani sparks row, *BBC News* [online]. 15 August 2012 [Accessed 8/6/2018] Available from: https://www.bbc.co.uk/news/world-europe-19267099

Anon, 2017. Corrado Formigli elogia CasaPound: "Un movimento vitale e pulito", *Giornalettismo* [online] 5 October 2017 [Accessed on 8/6/2018] Available from: https://www.giornalettismo.com/archives/2634456/corrado-formigli-casapound

Anon, 2017, "Per alcune ONG il tema è solo salvare vite umane": bufera sul Sen. Esposito, *La Repubblica* [online] 3/8/2017 [Accessed on 8/6/2018] Available from: http://www.repubblica.it/politica/2017/08/03/news/esposito_ong-172275786/?ref=RHP-PLF- BH-I0-C8-P4-S1.8-T1

Anon. 2018. Ai Weiwei defends Selfie with Far-Right AfD Leader, *Frieze* [online] 23 April 2018 [Accessed on 8/6/2018] Available from: https://frieze.com/article/ai-weiwei-defends-selfie-far-right-afd-leader

Anon, 2018. Italian Presidential Candidate Wants Annexation of Western Libya, *The Libya Times* [online]. 20 January 2018 [Accessed on 8/6/2018] Available from: http://www.libyatimes.net/news/98-italian-presidential-candidate-wants-annexation-of-western-libya

Anon. 2018. Italy: Is Salvini's League a Nazi Party? *Libcom.org*

[online] 21 July 2018 [Accessed on 25/8/2018] Available from: https://libcom.org/blog/italy-salvini-league-nazi

Anon. 2018. Right-wing group seeks to stop migrants crossing French Alps, *Infomigrants* [online] 24 February 2018 [Accessed on 8/6/2018] Available from: http://www.infomigrants.net/en/post/8834/right-wing-group-seeks-to-block-migrants-crossin g-french-alps

Anon. 2018. We'll rule for 30 years' says Salvini. *Ansa* [online] 2 July 2018 [Accessed on 17/8/2018] Available from: https://www.ansa.it/english/news/2018/07/02/well-rule-for-30-years-says-salvini-2_c4b2e95c-9265-49a7-88c7-f1f02e67f-c8b.html

Balmer, C. 2017, Italy's Renzi urges end to "do gooder" mentality on migrant influx, *Reuters* [online] 7/7/2017 [Accessed on 8/6/2018] Available from: https://www.reuters.com/article/us-europe-migrants-italy/italys-renzi-urges-end-to-do-gooder-mentality-on-migrant-influx-idUSKBN19S2PB

Bataille, G. 1979, The Psychological Structure of Fascism. *New German Critique, No. 16 (Winter, 1979)* [Accessed on 18/6/2018] Available from: http://www.lamarre-mediaken.com/Site/COMS_630_files/Bataille%20Fascism.pdf

Bellassai, S. 2018. Quale fascismo, quale antifascismo – Note sul Museo di #Predappio [online]. *Giap!* 8/6/2018 [Accessed on 11/6/2018] Available from: https://www.wumingfoundation.com/giap/2018/06/note-sul-museo-di-predappio/

Benjamin, W. 2008. *The Work of Art in the Age of Mechanical Reproduction*. London: Penguin Books.

Broder, D. 2018 Italy is the Future, *Jacobin Magazine,* [online]. 4 March 2018. [Accessed on 8/6/2018] Available from: https://www.jacobinmag.com/2018/03/italian-election-far-right-m5s-lega

Burchiellaro, D. 2017. Che cosa sai veramente delle donne di CasaPound? *MarieClaire* [online]. 3 November 2017 [Accessed on 8/6/2018] Available from: www.marieclaire.it/Attualita/

news-appuntamenti/chi-sono-le-donne-di-casapound

Cafasso, S. 2018. Populismo, de Benoist: "questa Lega non è mia figlia". *Lettera43* [online]. 9 April 2018 [Accessed on 9/6/29018] Available from: http://www.lettera43.it/it/articoli/politica/2018/04/09/de-benoist-lega-m5s-nouvelle-droite-fondazione-feltrinelli/219300/

Camilli, A. 2017, Migration and sexual abuse in Italy, inside a toxic news cycle, *Open Democracy* [online] 11/10/2017 [Accessed on 8/6/2018] Available from: https://www.opendemocracy.net/5050/annalisa-camilli/toxic-news-italy-migration-sexual-abuse

Camilli, A. 2018. *Josefa ha le unghie laccate perché nei quattro giorni di navigazione per raggiungere la Spagna le volontarie di Open Arms le hanno messo lo smalto per distrarla e farla parlare. Non aveva smalto quando è stata soccorsa. Serve dirlo? https://twitter.com/doluccia16/status/1020679077504733184.* [Twitter]. 22 July 2018. [Accessed on 17/8/2018]. Available from: https://twitter.com/annalisacamilli/status/1021065000348155904

Campi Fascisti [online]. [Accessed on 8/6/2018] Available from: http://www.campifascisti.it/mappe.php

Capriccioli, A. 2012. Roma, CasaPound spiazza tutti, *L'Espresso* [online]. 8 February 2012 [Accessed on 8/6/2018] Available from: http://espresso.repubblica.it/palazzo/2012/02/08/news/roma-casapound-spiazza-tutti-1.40175

Casaleggio Associati. 2008. *Gaia. The future of politics.* [online]. [Accessed on 28/9/2018] Available ot: https://www.youtube.com/watch?v=sV8MwBXmewU

CIRI, 2013. *All watched over by machines of loving grace - Episode 1 - Love and Power* [online] 3 December 2013 [Accessed on 4/8/2018] Available from: https://vimeo.com/groups/96331/videos/80799353

Clarke, H. 2018. Italy's Salvini channels Mussolini in tweet on late dictator's birthday. *CNN* [online] 30 July 2018 [Accessed on 16/8/2018] Available from: https://edition.cnn.

com/2018/07/30/europe/salvini-mussolini-italy-intl/index. html

ContraPoints. 2016. *Alpha Males* [online]. [Accessed 8/6/2018]. Available from: https://www.youtube.com/wat ch?v=k6jYB74UQmI

ContraPoints. 2017. *Does the Left Hate Free Speech? (Part 1)* [online]. [Accessed on 4/10/2018] Available from: https://www. youtube.com/watch?v=GGTDhutW_us

Dean, J. 2012. *The Communist Horizon*, London: Verso Books.

Denny, S. 2016. Blockchain Future States. *E-flux.* [online] 17 January 2017 [Accessed on 28/9/2018] Available from: https:// www.e-flux.com/architecture/superhumanity/68703/block-chain-future-states

Di Feo, G. 2009. Benvenuti a CasaPound, *L'Espresso* [online]. 22 May 2009 [Accessed on 8/6/2018] Available from: http:// espresso.repubblica.it/foto/2009/05/22/galleria/benvenuti-br-a-casa-pound-1.62487#1 Eco, U. 1995, Ur–Fascism, *The New York Review of Books*, [online] Volume 42, Number 11 [Accessed 8/6/2018] Available from: https://www.nybooks.com/ articles/1995/06/22/ur-fascism/

Esposito, F. *Fascism, Aviation and Mythical Modernity*. 2015. London: Palgrave Macmillan.

Etherington, D. 2018. Elon Musk's Boring Co. flamethrower is real, $500 and up for pre-order, *Techcrunch* [online] 28 January 2018 [Accessed on 8/6/2018] Available from: https://tech-crunch.com/2018/01/27/elon-musks-boring-co-flamethrower-is-real-500-and-up-f or-pre-order/?guccounter=1

Existential Comics, 2018. [online] 13 June 2018 [Accessed on 13/6/2018] Available from: https://twitter.com/existential-coms/status/1006702365280354304

Forza Nuova U.S.A. 2018. [online]. [Accessed on 8/6/2018] Available from: http://www.usa.forzanuova.info/what-is-forza-nuova/

Friedland, P. *Political Actors. Representative Bodies and Theatri-*

cality in the Age of the French Revolution. 2002. Ithaca, United States: Cornell University Press.

Giacomo Milazzo, 2011. *Piazzale Loreto* [online]. [Accessed on 9/6/2018] https://www.youtube.com/watch?v=wOCecmSa-M0

Gogarty, L. A. 2017. The Art Right, *Art Monthly*, 17 April. [Accessed on 8/6/2018] Available from: https://archive.ica.art/sites/default/files/downloads/The%20Art%20Right%20-%20Art%20M onthly%20April%202017.PDF

Groys, B. *In the Flow.* 2016. London: Verso Books.

Harris, C. 2018. How many migrants in your country? Probably fewer than you think. *Euronews* [online] 17 April 2018 [Accessed on 6/9/2018] Available from: http://www.euronews.com/2018/04/17/italians-and-much-of-the-eu-heavily-over-estimate-im migrant-numbers

Harris, C. 2018. Woman the sole survivor after migrant trio "abandoned" in Mediterranean. *Euronews* [online] 18 July 2018 [Accessed on 17/8/2018] Available from: http://www.euronews.com/2018/07/18/libyan-coast-guard-deny-the-accusation-they-abandon ed-migrants

hejjagheterpal, 2012. *Operation Gladio – Full 1992 documentary BBC* [online] 7 July 2012 [Accessed on 13/6/2018] Available from: https://www.youtube.com/watch?v=GGHXjO8wHsA

Inverse. 2016. *Elon Musk talks about the need to colonise Mars* [online]. [Accessed 8/6/2018] Available from: https://www.youtube.com/watch?v=3gTnBXoiHWc

Jesi, F. 1979. *Cultura di Destra*, Milano: Aldo Garzanti Editore.

Johnston, A. 2011. Libya 1911: how an Italian pilot began the air war era, *BBC News* [online]. 10 May 2011 [Accessed 8/6/2018] Available from: https://www.bbc.com/news/world-europe-13294524

Jones, S. 2018. Franco's cruel legacy: the film that wants to stop Spain forgetting, *The Guardian* [online]. 8/6/2018 [Accessed 9/6/2018] Available from: https://www.theguardian.com/

world/2018/jun/08/francos-cruel-legacy-film-wants-stop-spain-forgetting-silence-others

Jones, T. 2018. The fascist movement that has brought Mussolini back to the mainstream, *The Guardian* [online]. 22 February 2018 [Accessed on 8/6/2018] Available from: https://www.theguardian.com/news/2018/feb/22/casapound-italy-mussolini-fascism-mainstream

King, C. 2013. D'Annunzio and Il Vittoriale Degli Italiani: A Poet's Fantasy. *italy magazine*, [online] 15 April 2013 [Accessed on 16/8/2018] Available from: http://www.italymagazine.com/featured-story/dannunzio-and-il-vittoriale-degli-italiani-poets-fantasy

KOW. 2018. *Was euch am Leben hält, ist, was bei uns zu Asche zerfällt*. [online] 7 September 2018 [accessed on 16/9/2018] Available from: https://www.kow-berlin.com/exhibitions/das-was-euch-am-leben-halt-ist-das-was-bei-uns-zu-asche-zerfiel

La Colonie, 2018. *The White West. La Résurgence du Fascisme comme force Culturelle* [online]. [Accessed on 8/6/2018] Available from: http://www.lacolonie.paris/agenda/the-white-west-la-resurgence-du-fascisme-comme-force-culturelle

Laclau, E., Mouffe, C. 1985. *Hegemony and the Socialist Strategy – Towards a Radical Democratic Politics*, Edition 2014. London: Verso Books.

Laino, G. 2018. La blogger che ha diffuso la foto di Josefa con lo smalto stipendiata da CasaPound. *Giornalettismo* [online] 25 July 2018 [Accessed on 17/8/2018] Available from: https://www.giornalettismo.com/archives/2669868/francesca-totolo-casapound-josefa

Last, J. 2017. How "Hobbit Camps" rebirthed Italian Fascism, *Atlas Obscura* [online]. 3 October 2017 [Accessed on 8/6/2018] Available from: https://www.atlasobscura.com/articles/hobbit-camps-fascism-italy

Last Week Tonight. 2018. *Italian Election: Last Week Tonight: John Oliver (HBO)* [Accessed on 8/6/2018] Available from: https://

www.youtube.com/watch?v=LdhQzXHYLZ4&feature=you
tu.be&t=8m5s

Libcom. 2004-2018. *Strategy of Tension* [online]. [Accessed on 8/6/2018] Available from: https://libcom.org/tags/strategy-of-tension

Luther Blissett, 1994. [online]. [Accessed on 30/9/2018] Available from: http://lutherblissett.net/

Marinetti, F. 1909, Manifesto del Futurismo, *Le Figaro* 20/2/1909 [Accessed on 8/6/2018] Available from: https://www.unknown.nu/futurism/manifesto.html

Malkin, B. 2018. SpaceX Oddity: how Elon Musk sent a car towards Mars, *The Guardian* [online] 7 February 2018 [Accessed 8/6/2018] Available from: https://www.theguardian.com/science/2018/feb/07/space-oddity-elon-musk-spacex-car-mars-falcon-heavy

Marx, K. 1852. *The 18th of Brumaire of Napoleon Bonaparte* [online]. [Accessed on 9/6/2018] Available from: https://www.marxists.org/archive/marx/works/1852/18th-brumaire/ch01.htm

Mastrodonato, L. 2018. Aggressioni razziste dall'1 giugno 2018 – Insediamento nuovo governo [online] [Accessed on 16/8/2018] Available from: https://www.google.com/maps/d/viewer?mid=1kjmhct5NVKjSwAfo9OndqprhgQ6OEr8A&l l=45.56635623068137%2C9.849484062499982&z=5

Mouffe, C. 2018. Jeremy Corbyn's Left Populism, *Verso Blog* [online] 16 April 2018 [Accessed on 8/6/2018] Available from: https://www.versobooks.com/blogs/3743-jeremy-corbyn-s-left-populism

Mouffe, C., Eribon, D. 2017, Populism. A Dialogue on Art, Representation and Institutions in the Crisis of Democracy, *L'Internationale Online* [online] 8 June 2017 [Accessed on 8/6/2018] Available from: http://www.internationaleonline.org/dialogues/14_populism_a_dialogue_on_art_representation_and_institutions_in_the_crisis_of_democracy

Nagle, A. 2018. The Left Case against Open Borders, *American*

Affairs Volume II, Number 4 (Winter 2018): 17–30. [online]. [Accessed on 29/11/2018] Available from: https://americanaffairs-journal.org/2018/11/the-left-case-against-open-borders/

NASA. *The Golden Record.* [online] [Accessed on 30/9/2018] Available from: https://voyager.jpl.nasa.gov/golden-record/

NewFoundations, 2011. *The Educational Theory of Adolf Hitler* [online]. [Accessed on 8/6/2018] Available from: http://www.newfoundations.com/GALLERY/Hitler.html

Noys, B. 2014 *Malign Velocities – Accelerationism and Capitalism,* Winchester: Zero Books.

O'Toole, F. 2018. Fintan O'Toole: Trial runs for fascism are in full flow. *The Irish Times* [online] 26 June 2018 [Accessed on 25/8/2018] Available from: https://www.irishtimes.com/opinion/fintan-o-toole-trial-runs-for-fascism-are-in-full-flow-1.3543375?mode=amp

Occhipinti, M. 2004. Il centro sociale? Anche di Destra – Ecco le Occupazioni Non Conformi, *La Repubblica* [online]. 25 January 2004 [Accessed on 8/6/2018] Available from: http://ricerca.repubblica.it/repubblica/archivio/repubblica/2004/01/25/il-centro-sociale-anche-di-destra-ecco.rm_033il.html

Olterman, P., Kirchgaessner, S., and Tondo, L., 2017. Police who killed Berlin attacker made pro-fascist statements online, *The Guardian* [online]. 15 February 2017 [Accessed on 8/6/2018] Available from:https://www.theguardian.com/world/2017/feb/15/italian-police-killed-berlin-attacker-pro-fascist-statements-online

Pascarella, S. 2017. Il Format con la F. L'omicidio #Alatri e la violenza fascista che i media preferiscono ignorare, *Giap!* [online] 24 April 2017 [Accessed on 8/6/2018] Available from: https://www.wumingfoundation.com/giap/2017/04/omicidio-di-alatri-e-parola-con-la-f/

Pascoli, G. 1911, *La Grande Proletaria si è mossa* [online]. [Accessed on 18/6/2018] Available from: https://it.wikisource.org/wiki/La_grande_proletaria_si_%C3%A8_mossa

Paxton, R. O. 2005, *The Anatomy of Fascism*, New York: Vintage Books.

Raimo, C. 2018. Ritratto del neofascista da giovane, *Internazionale* [online]. 29 January 2018 [Accessed on 8/6/2018] Available from: https://www.internazionale.it/reportage/christian-raimo/2018/01/29/amp/neofascismo-scuola- ragazzi

Ross, A. R. 2017. *Against the Fascist Creep*, Chico, AK Press.

Salvia, M. 2018. Come la destra italiana sta rubando le icone della sinistra a suon di bufale. *Vice* [online] 19 July 2018 [Accessed on 16/8/2018] Available from: https://www.vice.com/it/article/pawpyb/icone-sinistra-rubate-destra-rossobruni-italiani

Samudzi, Z. 2018, What "Interracial" Cuckold Porn Reveals About White Male Insecurity, *Broadly*, [online]. 31 July 2018 [Accessed 12/8/2018] Available from: https://broadly.vice.com/en_us/article/594yxd/interracial-cuckold-porn-white-male-insecurity-race

SDLD50, 2018. *The Biennale of Very Fine People, on Both Sides* [Accessed on 7/10/2018] Available from: https://shutdownld50.tumblr.com/post/177951753921/the-biennial-of-very-fine-people-on-both-sides

Solari, R. 2012. *Fascist Legacy da History Channel* [online]. 11 September 2012 [Accessed on 9/6/2018] Available from: https://www.youtube.com/watch?v=2IlB7IP4hys&t=543s

Stanford University Libraries. 2018. *French Revolution Digital Archive*. [Online]. [Accessed on 22 September 2018]. Available from: https://frda.stanford.edu/

Steyerl, H. 2017. *Duty Free Art*, London: Verso Books.

Stuchbery, M. 2018. *A Day for Fear* [online]. 7 May 2018 [Accessed on 8/6/2018] Available from: http://mike-stuchbery.org/index.php/2018/05/07/a-day-for-fear/

Swift, D. 2017, Hanging out with the Italian neo-fascists who idolise Ezra Pound, *Literary Hub* [online]. 7 November 2017 [Accessed on 8/6/2018] Available from: https://lithub.com/hanging-out-with-the-italian-neo-fascists-who-idolize-ezra-

pound/

The Future of Work, 2016. *Alles Flex?* [online]. 20 May 2016 [Accessed on 9/6/2018] Available from: https://vimeo.com/167414979

Theweleit, K. 1987. *Male Fantasies – Women, Floods, Bodies, History.* University of Minnesota Press

Tondo, L., Giuffrida, A. 2018 Warning of "dangerous acceleration" in attacks on immigrants in Italy. *The Guardian* [online] 3 August 2018 [Accessed on 25/8/2018] Available from: https://www.theguardian.com/global/2018/aug/03/warning-of-dangerous-acceleration-in-attacks-on-immigrants-in-italy

Toscano, A. 2017. Notes on Late Fascism, *Historical Materialism* [online]. 2 April 2017 [Accessed 8/6/2018] Available from: http://www.historicalmaterialism.org/blog/notes-late-fascism

Turner, L. 2018 *An open letter to the participating artists and sponsors of the 2018 Athens Biennale.* [Accessed on 7/10/2018] Available from: http://luketurner.com/athens-biennale-2018-withdrawal/

Unitedagainstrefugeedeaths.eu. 2018. *List of Deaths.* [online]. [Accessed on 26/11/2018]. Available from: http://unitedagainstrefugeedeaths.eu/about-the-campaign/about-the-united-list-of-deaths/

Vanetti, M. 2018. Lotta di classe, mormorò lo spettro, *Giap!* [online]. 25/6/2018 [Accessed 14/8/2018] Available from https://www.wumingfoundation.com/giap/2018/06/marx-immigrazione-puntata-1/

Virgilio, M. 2015. *Futurismo e politica: Le origini, il confronto con Mussolini, lo scontro con Hitler.* [Kindle]

Wikipedia, 2002. *Propaganda Due* [online]. [Accessed on 13/6/2018] Available from: https://en.wikipedia.org/wiki/Propaganda_Due

Wikipedia, 2004. *La difesa della razza* [online]. [Accessed on 16/6/2018] Available from https://it.wikipedia.org/wiki/La_

difesa_della_razza

Wikipedia, 2005. *Golpe Borghese* [online]. [Accessed on 13/6/2018] Available from: https://en.wikipedia.org/wiki/Golpe_Borg hese

Wikipedia, 2006. *Dagospia* [online]. [Accessed pon 9/6/2018] Available from: https://it.wikipedia.org/wiki/Dagospia

Wikipedia, 2006. *Muscadin* [online]. [Accessed on 9/6/2018] Available from: https://en.wikipedia.org/wiki/Muscadin

Wikipedia. 2007. *Valerio Verbano* [online]. [Accessed on 8/6/2018] Available from: https://it.wikipedia.org/wiki/Valerio_Verbano

Wikipedia. 2011. *Acca Larentia killings* [online]. [Accessed on 8/6/2018] Available from: https://en.wikipedia.org/wiki/Acca_Larentia_killings

Wikipedia, 2011. *Yekatit 12* [online]. [Accessed on 8/6/2018] Available from: https://en.wikipedia.org/wiki/Yekatit_12

Willian, P. 2018. Matteo Salvini vows to clear Gypsies from Rome. *The Times* [online] 25 July 2018 [Accessed on 16/8/2018] Available from: https://www.thetimes.co.uk/article/salvini-vows-to-clear-gypsies-from-rome-79mxws80k

Wu Ming, 2013. Il più odiato dai fascisti. Conversazione su Furio Jesi, il mito, la destra e la sinistra, *Giap!* [online]. 15 January 2013 [Accessed on 8/6/2018] Available from: https://www.wumingfoundation.com/giap/2013/01/il-piu-odiato-dai-fascisti-conversazione-s u-furio-jesi/

Wu Ming 1, 2015. *Cent'anni a Nordest*, Milano: Rizzoli.

Wu Ming 1, 2018. Pasolini, Salvini e il neofascismo come merce, *Internazionale* [online]. 4 June 2018 [Accessed on 8/6/2018] Available from: https://www.internazionale.it/opinione/wu-ming-1/2018/06/04/pasolini-salvini-neofascismo

Wu Ming 1, 2016. *The police vs. Pasolini, Pasolini vs. the police* [online]. [Accessed on 8/6/2018] Available from: https://www.versobooks.com/blogs/2719-the-police-vs-pasolini-pasolini-vs-the-police

Wu Ming 4, 2010-2018. Archives for JRR Tolkien, *Giap!* [online]. [Accessed on 8/6/2018] Available from: https://www.wumingfoundation.com/giap/tag/jrr-tolkien/

Zapperi, G. 2018. *Myth versus history: some notes on Italian Futurism.* 17 March 2018, BAK Utrecht

Zetazeroalfa. 2007. Cinghiamattanza – Official Video [online]. [Accessed on 8/6/2018] Available from: goo.gl/yXoWwq

CULTURE, SOCIETY & POLITICS

The modern world is at an impasse. Disasters scroll across our
smartphone screens and we're invited to like, follow or upvote,
but critical thinking is harder and harder to find. Rather than
connecting us in common struggle and debate, the internet has
sped up and deepened a long-standing process of alienation and
atomization. Zer0 Books wants to work against this trend.
With critical theory as our jumping off point, we aim to publish
books that make our readers uncomfortable. We want to move
beyond received opinions.
Zer0 Books is on the left and wants to reinvent the left. We are
sick of the injustice, the suffering, and the stupidity that defines
both our political and cultural world, and we aim to find a new
foundation for a new struggle.

If this book has helped you to clarify an idea, solve a problem or
extend your knowledge, you may want to check out our online
content as well. Look for Zer0 Books: Advancing Conversations
in the iTunes directory and for our Zer0 Books YouTube channel.

Popular videos include:

Žižek and the Double Blackmain

The Intellectual Dark Web is a Bad Sign

Can there be an Anti-SJW Left?

Answering Jordan Peterson on Marxism

Follow us on Facebook
at https://www.facebook.com/ZeroBooks and Twitter at https://twitter.com/Zer0Books

Bestsellers from Zer0 Books include:

Give Them An Argument
Logic for the Left
Ben Burgis
Many serious leftists have learned to distrust talk of logic. This is a serious mistake.
Paperback: 978-1-78904-210-8 ebook: 978-1-78904-211-5

Poor but Sexy
Culture Clashes in Europe East and West
Agata Pyzik
How the East stayed East and the West stayed West.
Paperback: 978-1-78099-394-2 ebook: 978-1-78099-395-9

An Anthropology of Nothing in Particular
Martin Demant Frederiksen
A journey into the social lives of meaninglessness.
Paperback: 978-1-78535-699-5 ebook: 978-1-78535-700-8

In the Dust of This Planet
Horror of Philosophy vol. 1
Eugene Thacker
In the first of a series of three books on the Horror of Philosophy,
In the Dust of This Planet offers the genre of horror as a way of
thinking about the unthinkable.
Paperback: 978-1-84694-676-9 ebook: 978-1-78099-010-1

The End of Oulipo?
An Attempt to Exhaust a Movement
Lauren Elkin, Veronica Esposito
Paperback: 978-1-78099-655-4 ebook: 978-1-78099-656-1

Capitalist Realism
Is There no Alternative?
Mark Fisher
An analysis of the ways in which capitalism has presented itself
as the only realistic political-economic system.
Paperback: 978-1-84694-317-1 ebook: 978-1-78099-734-6

Rebel Rebel
Chris O'Leary
David Bowie: every single song. Everything you want to know,
everything you didn't know.
Paperback: 978-1-78099-244-0 ebook: 978-1-78099-713-1

Kill All Normies
Angela Nagle
Online culture wars from 4chan and Tumblr to Trump.
Paperback: 978-1- 78535-543-1 ebook: 978-1-78535-544-8

Cartographies of the Absolute
Alberto Toscano, Jeff Kinkle
An aesthetics of the economy for the twenty-first century.
Paperback: 978-1-78099-275-4 ebook: 978-1-78279-973-3

Malign Velocities
Accelerationism and Capitalism
Benjamin Noys
Long listed for the Bread and Roses Prize 2015, *Malign Velocities*
argues against the need for speed, tracking acceleration
as the symptom of the ongoing crises of capitalism.
Paperback: 978-1-78279-300-7 ebook: 978-1-78279-299-4

Meat Market
Female Flesh under Capitalism
Laurie Penny
A feminist dissection of women's bodies as the fleshy fulcrum of
capitalist cannibalism, whereby women are both consumers and
consumed.
Paperback: 978-1-84694-521-2 ebook: 978-1-84694-782-7

Babbling Corpse
Vaporwave and the Commodification of Ghosts
Grafton Tanner
Paperback: 978-1-78279-759-3 ebook: 978-1-78279-760-9

New Work New Culture
Work we want and a culture that strengthens us
Frithjoff Bergmann
A serious alternative for mankind and the planet.
Paperback: 978-1-78904-064-7 ebook: 978-1-78904-065-4

Romeo and Juliet in Palestine
Teaching Under Occupation
Tom Sperlinger
Life in the West Bank, the nature of pedagogy and the role of a
university under occupation.
Paperback: 978-1-78279-637-4 ebook: 978-1-78279-636-7

Ghosts of My Life
Writings on Depression, Hauntology and Lost Futures
Mark Fisher
Paperback: 978-1-78099-226-6 ebook: 978-1-78279-624-4

Sweetening the Pill
or How We Got Hooked on Hormonal Birth Control
Holly Grigg-Spall
Has contraception liberated or oppressed women?
Sweetening the Pill breaks the silence on the dark side of hormonal
contraception.
Paperback: 978-1-78099-607-3 ebook: 978-1-78099-608-0

Why Are We The Good Guys?
Reclaiming your Mind from the Delusions of Propaganda
David Cromwell
A provocative challenge to the standard ideology that Western
power is a benevolent force in the world.
Paperback: 978-1-78099-365-2 ebook: 978-1-78099-366-9

The Writing on the Wall
On the Decomposition of Capitalism and its Critics
Anselm Jappe, Alastair Hemmens
A new approach to the meaning of social emancipation.
Paperback: 978-1-78535-581-3 ebook: 978-1-78535-582-0

Enjoying It
Candy Crush and Capitalism
Alfie Bown
A study of enjoyment and of the enjoyment of studying. Bown asks what enjoyment says about us and what we say about enjoyment, and why.
Paperback: 978-1-78535-155-6 ebook: 978-1-78535-156-3

Color, Facture, Art and Design
Iona Singh
This materialist definition of fine-art develops guidelines for architecture, design, cultural-studies and ultimately social change.
Paperback: 978-1-78099-629-5 ebook: 978-1-78099-630-1

Neglected or Misunderstood
The Radical Feminism of Shulamith Firestone
Victoria Margree
An interrogation of issues surrounding gender, biology, sexuality, work and technology, and the ways in which our imaginations continue to be in thrall to ideologies of maternity and the nuclear family.
Paperback: 978-1-78535-539-4 ebook: 978-1-78535-540-0

How to Dismantle the NHS in 10 Easy Steps (Second Edition)
Youssef El-Gingihy
The story of how your NHS was sold off and why you will have to buy private health insurance soon. A new expanded second edition with chapters on junior doctors' strikes and government blueprints for US-style healthcare.
Paperback: 978-1-78904-178-1 ebook: 978-1-78904-179-8

Digesting Recipes
The Art of Culinary Notation
Susannah Worth
A recipe is an instruction, the imperative tone of the expert, but this constraint can offer its own kind of potential. A recipe need not be a domestic trap but might instead offer escape – something to fantasise about or aspire to.
Paperback: 978-1-78279-860-6 ebook: 978-1-78279-859-0

Most titles are published in paperback and as an ebook. Paperbacks are available in traditional bookshops. Both print and ebook formats are available online.
Follow us on Facebook
at https://www.facebook.com/ZeroBooks
and Twitter at https://twitter.com/Zer0Books